CW00740153

REALLY GOOD

DOG

PHOTOGRAPHY

PARTICULAR BOOKS

UK | USA | Canada | Ireland | Australia
India | New Zealand | South Africa

Particular Books is part of the Penguin Random
House group of companies whose addresses can
be found at global.penguinrandomhouse.com.

Penguin
Random House
UK

First published 2017
001

Texts copyright © Lucy Davies, 2017
Photographs © the individual photographers, 2017

The moral right of the author has been asserted

Images selected and curated by Martin Usborne
Creative consultant Marta Roca, *Four&Sons* magazine

Designed by Tom Etherington
Printed in Italy by Graphicom Srl

Cover image:
Street Dogs, *Daryl*, San Felipe, Mexico, 2007 by Traer Scott

A CIP catalogue record for this book is available
from the British Library

ISBN: 978–1–846–14942–9

REALLY GOOD

DOG

PHOTOGRAPHY

Written by Lucy Davies

HOXTON MINI PRESS
x
PENGUIN BOOKS

Introduction

Dogs and photography have gone hand in paw almost since the medium was invented, in 1839. Before dust had even settled on the first photographic prints, devoted owners were hauling their dogs in front of cameras, intent on preserving their furry, four-legged friends for posterity.

Most subjects took an almost comical approach to eluding capture, appearing next to their master or mistress as a blurry smudge. But they could hardly be blamed. Exposure time was exasperatingly long and they were probably excited by the considerable attention a portrait sitting involved.

It wasn't unheard of for dogs to be sedated in the studio. Certainly the hobbyists and tinkerers who reported their experiments in the journals of the day were not above discussing the merits of drugging children to make them sit still, and why stop there? There are reports of an itinerant photographer in America dosing his canine sitters with whisky, which must have made them awfully sick.

Both ethics and exposure times have improved since, but our passion for photographing dogs is undiminished. Last year we uploaded nearly 200 million pictures with the hashtags #dog and #puppylove to the photo-sharing app Instagram, which far outstrips the measly 13 million of our #brunch. According to Google, when it comes to questions about animal photography, the search term 'dog' beats all other species hands down.

But, in the modern world, photography has become less about preserving, more about conveying. And cute, happy and shiny-coated seem to be the things we want to convey. The appetite for those qualities, particularly online, is staggering.

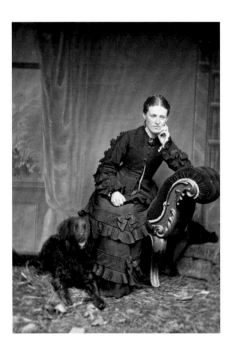

For those without a dog of their own, following the daily romps of Burrito the corgi, or the sartorial élan of Menswear Dog via their social media accounts may offer some of the testified benefits of dog ownership (reduced rates of stress, depression and heart disease) without having to actually go for a walk in the howling wind or bear the indignity of a pooper hoover. Dogs are affectionate, positive, go-getting types; the visual embodiment of love, loyalty, enthusiasm and fun. For five minutes we can live in a world that isn't competitive, that doesn't involve commuting or meetings, career ladders or mortgage rates.

In many of these photos, though, dogs are made human-like and infantilized. They bear little resemblance to the dignified creature on which artists have lavished acres of canvas and paint over many hundreds of years. In the artworks including dogs to be found around every corner in the National Gallery, the Louvre, Frick and Prado, the impression is of an altogether different animal: an elegant, handsome and noble thing, something to be pored rather than cooed over.

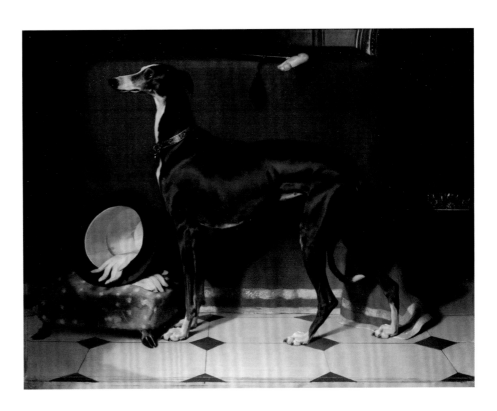

The photographs in this book offer an alternative to all the fluff and slobber. They have been chosen because, like their painterly antecedents, they approach the dog as a sentient, intelligent and mortal being and because they consider the relationship that has formed between dogs and humans for the extraordinary and intriguing thing it really is. Many of them also address the issues facing dogs and their owners in the modern world. In effect: they restore photographs of dogs to the fold of fine art.

That's not to say they are humourless, or worthy, or even grandiose. Many are charming, even comical. Some conjure brilliantly the rural harmonies we left behind long ago, others the value working dogs continue to play in our lives, even in these technology-focused times. Time and again they reflect on how a creature that is a third of our size, and which cannot speak our language, still succeeds in quelling our deepest fears and anxieties.

In truth, if ever there was a time we needed to surround ourselves with fitting imagery of dogs, it is now. Here in the UK, we own nine million of them. In France, Italy and South Africa, it's about seven million. The USA tops the list, with 70 million, where the number of households with a pet is almost double the number with a child. That's an awful lot of dogs.

As conventional family structures continue to founder (more people now choose to live alone, marry later, have fewer children), pups are steadily filling the vacuum. They provide us with emotional support, obey (most of)

Left: Lengthy exposure times during the early days of photography meant that this dog, captured with his mistress in a portrait studio in 1875, failed to sit still long enough to be captured in detail.

Above: Commissioned by Queen Victoria as a surprise Christmas present for Prince Albert in 1841, this painting by Sir Edwin Landseer depicts Albert's favourite greyhound, Eos, alongside her master's gloves, hat and cane.

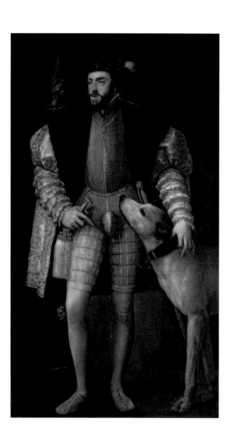

our commands and, in return, we treat them as members of the family. Arguably we treat them better than our children; certainly better than we treat the elderly.

Surveys conducted in both the UK and the US last year reveal that many owners would feel more devastated by a dog running away than the break-up of a long term relationship. More than half of dog owners admit to buying their pets a Valentine's Day present. Indeed, spending on dog-related merchandise has outstripped the high-street average for years. In fact, it's positively booming. From chiffon harnesses, to doggy cupcake kits, anxiety-relieving tonics, 'pawdicures', dog yoga classes, dog therapists (to treat separation anxiety and depression), even exhibitions of contemporary art and a television channel designed specifically for four-legged viewers, the canine marketplace boasts everything to fill your needs, and then some.

All of which begs the question, why, in this day and age, are neglect and abandonment still an issue? The British rehoming charity Dogs Trust handles around 45,000 calls each year from people trying to give up their pets. And the RSPCA picked up 102,363 strays last year, of which only about half were reunited with their owners. That leaves many thousands of dogs that weren't. Space in UK shelters is limited: every day, twenty-one dogs have to be euthanized. In the US, where the problem is much worse (the ASPCA estimates 3.3 million dogs enter shelters each year), that figure is closer to 1,800 per day.

Where does this obsessive, contradictory behaviour concerning dogs come from? We can't lay everything at the internet's feet. These attitudes and actions are ingrained in our culture, inherited from schmaltzy china sets and biscuit tins, in myths such as Greyfriars Bobby (a terrier who supposedly watched over his master's grave for fourteen years), in children's literature, television and Hollywood. From *Lassie* and *The Adventures of Rin Tin Tin* via *Old Yeller*, *The Littlest Hobo*, *Hooch*, *Beethoven*, *Dog with a Blog*, we're steeped in half-truths and fables. It's no wonder our expectations have become muddled.

The idea of the dog as a cosseted being, wholly recused from strenuous labour, is Victorian. Prior to that, unless you were very rich (usually a member of the court) a dog would first and foremost have been a replaceable animal that had to herd, hunt or protect for its living.

But at around the same time that William Henry Fox Talbot was up to his elbows in salts and acids attempting to fix the first photographs on paper, two other important adjustments to our way of seeing the animal world were afoot, adjustments that would have a profound effect on our dealings with dogs.

First, animals began to disappear from daily life. Slaughterhouses and livestock markets were expelled from the centre to the outlying edges of the city, chiefly so that society's growing squeamishness about the killing of animals could be assuaged. Animals bred for use – with the exception of horses – disappeared almost entirely from view. Then, in 1839 – the same year that Fox Talbot announced his findings to the Royal Society – carts and barrows pulled by dogs were banned within fifteen miles of London's Charing Cross station. Compassion towards dogs was suddenly seen as civilized, whereas cruelty suggested moral delinquency.

That same year and less than a mile away, in Soho, the naturalist Charles Darwin opened his first notebook on the transmutation of species. He had recently returned from his voyage aboard the brig-sloop *Beagle*, and on his desk lay specimens awaiting identification.

A dog lover to the last (he owned five terriers, a retriever, a Pomeranian, a pointer and a deerhound), many of Darwin's ideas were explained by analogies with dogs. Indeed it was partly the Victorian mania for breeding

dogs (an encyclopaedia of dogs published in 1800 lists twenty-three breeds; by the end of the century, the number was nearer 350) which led him to question the effect of such interventions on innate instincts. The first conformation dog show, in which breeds are measured according to a prescribed standard, was held in Newcastle in 1859, the same year Darwin published *On the Origin of Species*.

All of these ideas concerning dogs – their looks, their nature, our treatment of them and our relation to them – were bubbling away at the surface of Victorian life, trickling slowly into established codes of behaviour. To those unmoored by Darwin's ideas concerning natural selection, what better way to refute the idea of 'Nature, red in tooth and claw' than lavishing care on a fluffy parlour pet? The smaller breeds in particular became quite as fashionable as a box at the opera, as did doggy accessories. By 1840, London boasted fourteen shops specializing in ornamental collars.

The women of the realm had Queen Victoria's example to follow. The newly crowned monarch was hopelessly in love with dogs. Hours after her coronation, in 1838, she was discovered giving her spaniel, Dash, his usual bath.

Among the menagerie of animals that later belonged to her and Prince Albert were collies, deerhounds, greyhounds, terriers and mastiffs, and she introduced two new breeds to Britain: the Pekingese and the Pomeranian. At one time she had thirty-five of the latter. Turi was her favourite, and he

Left: Renaissance paintings teem with dogs, especially hunting dogs. Here the Holy Roman Emperor Charles V is pictured with his loyal hound, whose lustrous coat matches that of his equally doting owner (note the left thumb, which Titian, who painted the portrait in 1533, shows fondling the dog's neck).

Below: Diego Velázquez's 1656 ensemble portrait of the family of King Philip IV, named for the maids – '*Las Meninas*' – fussing over the Infanta Margarita, includes one of the royal hunting dogs in a prominent position at the front of the canvas.

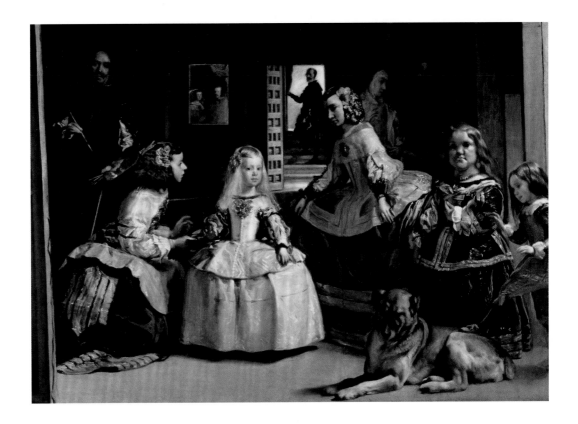

travelled everywhere with her, nestled on her lap among the great folds of black bombazine. Legend has it he was on her bed when she drew her last breath.

But if the notion of keeping animals regardless of their usefulness is a nineteenth-century invention, dogs have been close to the heart of humankind for very much longer, and to understand the complexity of that relationship, we need to go back thousands rather than a couple of hundred years.

Before we learned to sow and reap wheat; before we hammered spear-heads or shifted counters on the abacus, we fell into partnership with the grey wolf. Popular theory has it that it was the wolf rather than us that chose to initiate an alliance, by hovering at the edges of the fire, eating our surplus meat and then deigning to allow us to domesticate it.

In turn, they helped us eat, carry, labour and stay alive. Without dogs, humans would never have enjoyed the feeling of safety that allowed them to evolve from hunter-gatherers into farmers with permanent settlements. But far more intriguing – and romantic – is that dogs soon became a means of charting the world and understanding its many peculiarities. They inspired the names of the constellations. Plato assures us that behind those goofy faces they were actually first-rate philosophers. The Egyptians made them gods. In Classical mythology they guarded the underworld and waited ten years for their master to return home. In Arthurian Legend they could see the wind, and for Aesop they offered instruction in the art of contentment.

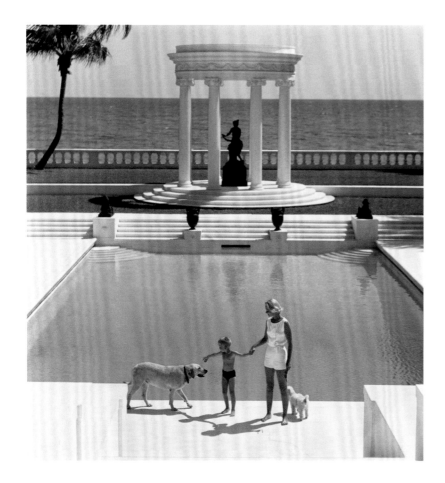

The love that flourished between our two species must have happened early on, as evidenced by the number of prehistoric people who chose to be buried *per canem*, presumably so they could enter the afterlife together. Dogs were often interred with a bone or a blanket.

What seems to have cemented the relationship is the dog's skill at reading our patterns of behaviour and our moods, then learning and anticipating them. It's made us think they are crazy about us. Many are the dog owners who insist their pet completes and understands them in a way no other person can. 'The average pet owner … can be to his pet what he is not to anybody or anything else,' wrote John Berger, in his book *Why Look at Animals?* (1980). Furthermore, 'the pet can be conditioned to react as though it, too, recognizes this. The pet offers its owner a mirror to a part that is otherwise never reflected'.

Perhaps it's only natural that so many creatively inclined minds, whether poets or painters, have sought to puzzle out this unique and mutually rewarding *entente*. The history of art is certainly rich with examples. Those sixteenth-century dukes, emperors and kings portrayed by master portraitists such as Titian, Anthony van Dyck and Diego Velázquez often have a dog at their side. As was the custom at the time, the animal's presence came loaded with symbolism. Nobility, loyalty and tenaciousness were canine attributes.

Intriguingly, hordes of artists have also chosen to paint themselves in the company of a dog. Many more still were owners themselves, including Rembrandt van Rijn, Thomas Gainsborough, William Hogarth, Gustave

Above: Laika, the first living being to be sent into orbit, was one of several Soviet dogs who took giant leaps for mankind during the 1950s and 1960s. She became a cult hero, her image plastered over cigarette packets, toys and household items.

Left: C. Z. Guest, a horsewoman, author and socialite, with her young son and dogs in front of the swimming pool of the Villa Artemis in Palm Beach, 1955. The photographer, Slim Aarons, was renowned for his images of the upper classes enjoying the good life.

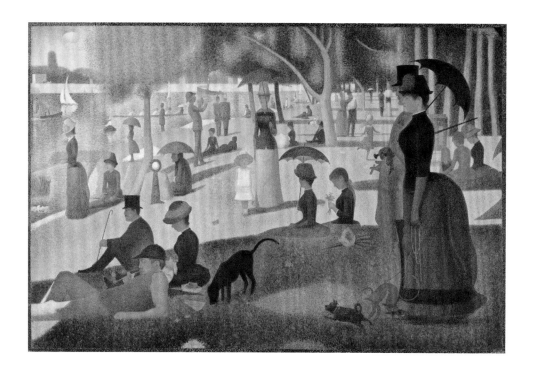

Courbet, Edwin Landseer, Pablo Picasso, Frida Kahlo, Norman Rockwell, Andy Warhol, Jackson Pollock, Lucian Freud and David Hockney. Perhaps it's because the companionship and affirmation a warm dog offers is a panacea for the lonely life of an artist. Perhaps dogs simply ground a flight-prone mind.

It wasn't until the seventeenth century, when Dutch and Flemish artists began focusing on everyday life, rather than history or myth, that any sign of a dog's real pursuits and nature began to appear. In these kinds of paintings they are pictured at the market, drooling over cuts of meat, or watching the kitchen maids at work, even urinating on the pillars at the back of churches.

Here in England, it was George Stubbs who led the dog to centre stage. Though horses were his first love, dogs ran a close second, and he was one of the first to approach them as beings with their own special character and beautiful form, rather than as generic or symbolic.

Given the domestic dog's sudden prominence in the mid-nineteenth century, it's unsurprising that the same era gave rise to a sort of heyday for dogs in art. Landseer's hyper-realistic (if at times uncomfortably anthropomorphic) portraits lined the walls of many of the royal residences. And John Singer Sargent made no bones about his love of dogs. His loose, lively brushwork was perfect for capturing the wriggling Yorkshire Terrier belonging to Beatrice Townsend, for example. Though its paw is clamped in his mistress's hand, the dog seems moments away from making his escape.

Something I'd never noticed before researching this book is the number of dogs hiding in plain sight in the works of the Impressionists. There they are on the Japanese bridge in Claude Monet's garden at Giverny; in the

foreground of Auguste Renoir's *Luncheon of the Boating Party*; lying on the riverbank of Georges Seurat's *La Grande Jatte*, crouched by the sides of tables and even under the bath in the domestic scenes favoured by Pierre Bonnard.

Andy Warhol, Lucian Freud and David Hockney, three of the most influential artists of the twentieth century, were and are great dog-lovers. With Hockney and Freud particularly, the tenderness of the connection radiates from every stroke. Freud once said that he was 'interested in people as animals … I like people to look as natural and as physically at ease as animals, as Pluto my whippet'.

Given the varied and reverential treatment dogs have received from artists over the centuries, it's odd that the history of photography has failed to produce any comparable examples. Certainly, if dogs appear, they are almost never the main focus, and only ever considered in relation to their human owners.

August Sander's early twentieth-century catalogue of the people living in and around Cologne, classified according to profession and class, included a subset of men with their dogs. Sander was interested in types and how those might represent the social order, so the matching of breed and profession seems pronounced – the schoolteacher with his friendly, practical dog, the showman with his rough dog, the notary with his refined breed, and so on.

Diane Arbus sometimes included dogs in her photographs of people – her Lady Bartender, for example, and her Carnival Hermaphrodite. Usually it was a means of suggesting we should re-evaluate initial impressions or preconceived ideas. In the case of Blaze Starr (1964), the body of the notorious burlesque performer is captured mid-shimmy in her living room,

Left: Georges Seurat's 1886 painting *La Grande Jatte* includes no fewer than three dogs hidden among its cast of fifty-odd wealthy Parisians enjoying a Sunday afternoon on the banks of the river Seine.

Below: Working dogs play a pivotal role in military operations, serving in every major conflict since the First World War. The Australian photographer Adam Ferguson, whose sustained survey of the US-led occupation of Afghanistan has won several awards, spent several months capturing the special bond that develops between these canine combat dogs and their handlers.

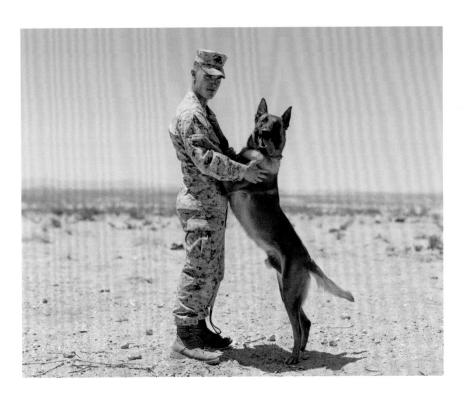

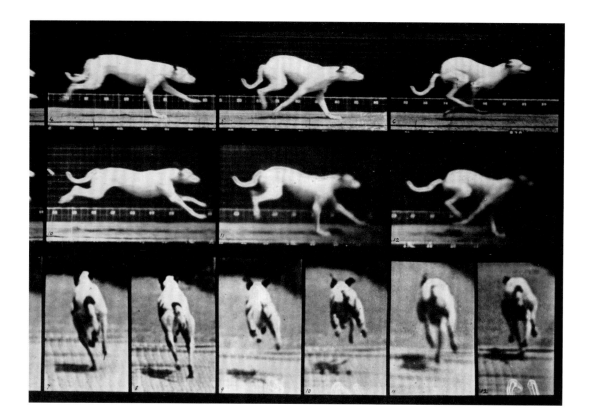

but, just behind, sits her tiny white dog looking distinctly puzzled. Along with her perfectly placed cushions, house plants and macramé, the pup marks her out as much more bourgeois housewife than aloof temptress.

Keith Arnatt's 1976–9 series *Walking the Dog*, in which dog owners local to the photographer's hometown of Tintern, Monmouthshire, are depicted full length with their dog at their feet, is probably the only truly dog-centric work. The black-and-white images gain everything in being side by side, where repetition underscores both owner and dog's individuality. They're overflowing with period detail, too: all flared trousers, sheepskin and shaggy hair.

Truly, the time is ripe for new ways of seeing and portraying the dog. For one, in tandem with huge advances in the field of photography, the twentieth century has brought with it scrutiny of the dog's inner life. Whether dogs remember much beyond yesterday, for example; whether they dream, experience jealousy or guilt, or whether they empathize.

We know now that they have the same brain structures that produce emotions in humans, and that those structures undergo the same chemical changes as ours do. Love, joy, fear, anger, disgust, excitement and distress are all within their range, which must – eventually – have an effect on the way we rear and treat our dogs, as well as what we expect of them.

The best of the work being produced today considers whether our understanding of dogs can ever be more than conjecture. Whether in the spirited shadows captured by Thomas Roma at his neighbourhood dog park;

Above: Dogs were some of the many animals photographed by Eadweard Muybridge for the ground-breaking studies of animal locomotion he conducted between 1872 and 1885.

John Divola's sketch-like capture of the dogs who chase his car in the California desert; Dougie Wallace's tongue-in-cheek survey of the canine mega-elite, or the anonymous couple who spent a lifetime trying to photograph their obdurately un-photographable black dog, the images on the following pages open our eyes to a far wider, more nuanced and ultimately far more rewarding view of our closest animal companion.

It is only a view, though. We may think we understand them, but ultimately our judgement of a dog and its behaviour and intellect is almost always affected by our own way of perceiving the world. 'We seem to judge the worth of every animal on the planet, according to what they can give us or how much they resemble us,' explains the American photographer Traer Scott, who has been making portraits of dogs almost her entire life. 'Can they think like us? Can they feel like us? It's the wrong way to look at it because we're not acknowledging their innate worth. There are so many different kinds of intelligence in animals that are nothing like ours. However much we like to think we understand them, they probably understand us better.'

Charlotte Dumas

THE SEARCH-AND-RESCUE DOGS WHOSE HEROIC EFFORTS
AT GROUND ZERO ON 9/11 PROVIDED THE WORLD WITH
A SPARK OF HOPE AMONG THE DEVASTATION

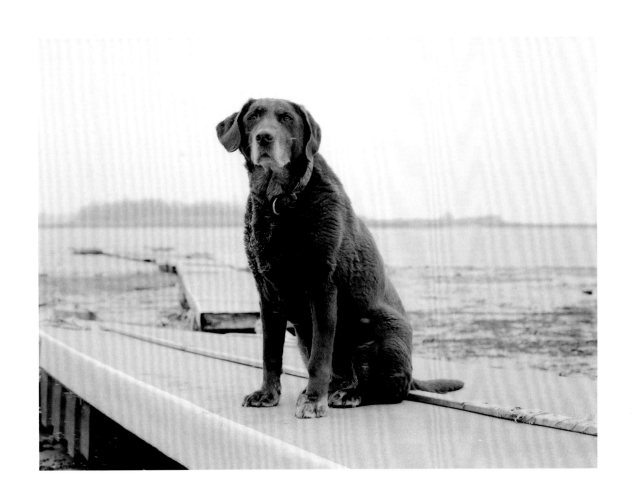

Charlotte Dumas was at home in Amsterdam on September 11, 2001, when 2,823 people were killed in the terrorist attack on New York's World Trade Center. She saw the second plane crash into the South Tower on her television screen. 'I remember the feeling so well,' she says. 'It seemed as if it was the end of an era.'

Over the following few days, as images of the destruction and its aftermath scarcely left the front pages, Dumas was struck particularly by pictures of the search-and-rescue dogs engaged at Ground Zero. 'A dog being transported in a basket on cables suspended high over the wreckage; the special shoes made for them so they could manoeuvre over hot metal beams; the eye drops they received in between shifts – I can still recall these clearly.'

Ten years later, Dumas, who is admired for a body of work in which the animal's 'voice' is always given precedence over the photographer's, was invited to make portraits of working dogs in Liguria, Italy. One of these was a very elderly dog who had formerly assisted a coastguard. 'It made me remember the dogs of 9/11,' she says. 'How many were still left? Soon, these animal witnesses would be gone and, with that, part of our experience, too.'

On her return, Dumas contacted America's Federal Emergency Management Agency (FEMA), the organization which had employed the principal rescue team for 9/11. Discovering that fifteen of the dogs were still alive, over the next three months she travelled to places such as Indiana, California, Texas, Missouri, Massachusetts and Virginia to take their portraits. Because she wanted to portray them in their own environment, she would usually go for a walk with the dog and their owner first, a process which helped relax the animal, too. Though the animals displayed the vulnerability of old age, 'I don't think they were traumatized by the search-and-rescue operation in the same way their human counterparts were,' says Dumas. 'I'm sure it requires a specific character to be a good search dog but, generally, dogs are very resilient and have an outstanding capacity to adapt to any situation – this is something I have found to be true of all the working animals I have encountered.'

Though most of the dogs had continued working after 9/11, by the time Dumas took their portraits they had been retired for some time. Since then, all of them have passed away. The last, Bretagne, a golden retriever from Harris County in Texas, was given a hero's farewell by local firemen when she died in 2016.

In all, there were nearly a hundred dogs at Ground Zero, working twelve hours a day, for two weeks straight. Even though, in the end, their search for survivors was in vain (it became clear very quickly that they were finding only remains), nevertheless, the dogs provided a comfort which those managing the disaster's aftermath had not anticipated.

'They gave consolation to anyone involved,' explains Dumas, 'and not just the workers on site but to all of us witnessing the news. Seeing those pictures, I was also comforted. They somehow emanated a spark of hope amid these scenes of destruction. Maybe it was as important as their actual search work.'

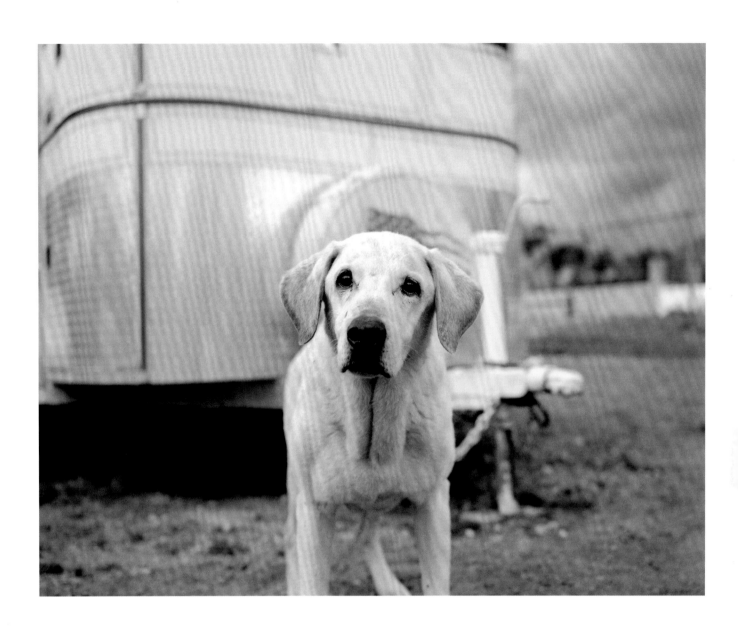

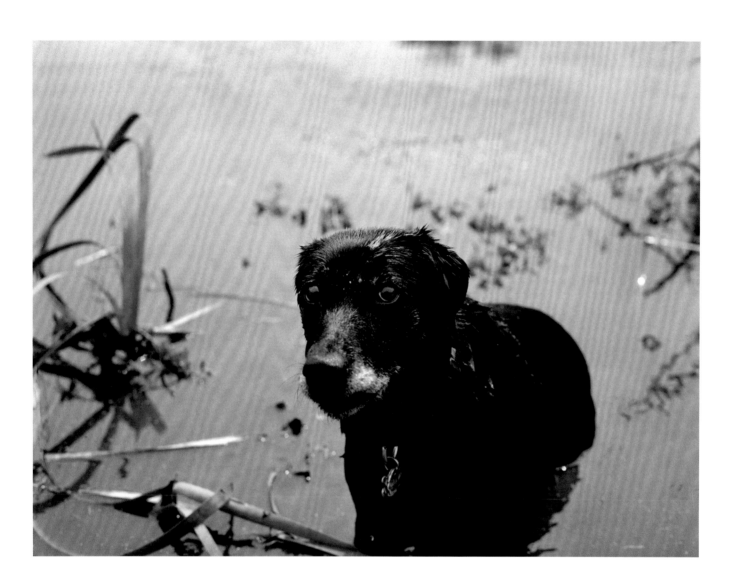

RETRIEVED, BAILEY, FRANKLIN, TN, 2011

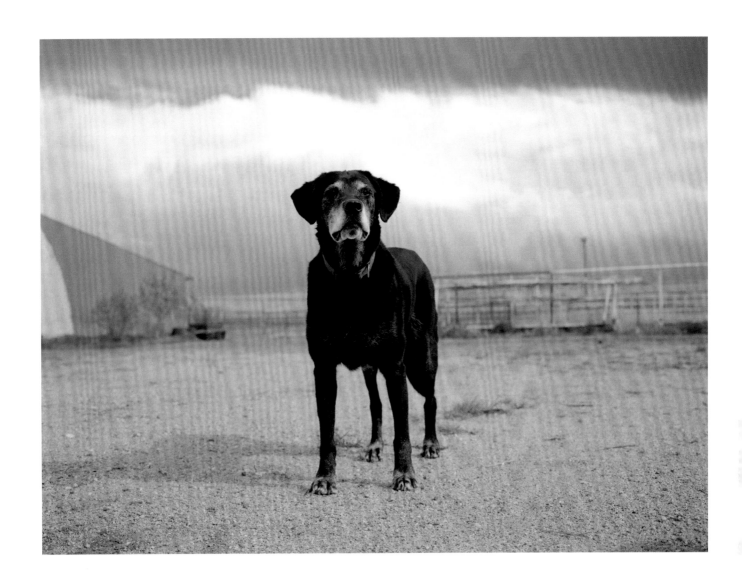

RETRIEVED, ORION, VACAVILLE, CA, 2011

William Wegman

A CHARMING AND VERY WITTY
TESTAMENT TO THE UNCOMMON RAPPORT
BETWEEN ONE MAN AND HIS DOG(S)

'I wasn't sure I wanted a dog, but my wife did, so we flipped a coin. Five times in a row it came up tails.'

At seventy-three, William Wegman is many things: a gifted painter, a pioneer video artist and performer, an author and an extremely funny parodist. But he will forever be best known for the photographs of Weimaraners that he began taking in the seventies.

The first of his silken-grey troupe was Man Ray, named after the American surrealist and blessed with a magnificent poker-face. Together, he and Wegman formed one of the greatest artistic partnerships in history, spurring each other on to ever more waggish heights. Man Ray dusted with flour, for example, or idling in a modernist chair; even undergoing a real talking to after failing his spelling test.

But it might never have happened. 'I wasn't sure I wanted a dog,' says Wegman, 'but my wife did, so we flipped a coin. Five times in a row it came up tails. I remember the feeling of him in my lap on the drive home – he was only six weeks old, but plump. When we arrived, I laid him on the bed and took his picture. I think that started the whole thing: from then on, that was what we did together.'

Man Ray was smart. He also had creative flair. 'He would decide on these themes and keep finding things for me to photograph – one month, it was cones, for example. And he would just do things that dogs have never done before, like, when I was driving, he would sit in the passenger seat and look at my feet and my hands, as if he was trying to figure out if he could do it.'

The work the pair made together, which has become a kind of gold standard in dog portraiture, made them the toast of the art scene, on both East and West coasts. So much so that in 1982, the year Man Ray died, *Village Voice* ran a full-page photo, naming him 'Man of the Year'.

Wegman has had ten other Weimaraners since – Fay Ray, Batty (Battina), Crooky, Chundo, Chip, Bobbin, Candy, Penny, Flo and Topper. He loves their coats, particularly. 'They kind of glow,' he explains, 'and they reflect the light, so their colour changes a bit, depending on whether they're outside or inside. If I use a set paper in the studio, they become almost infused with that colour.'

They have always slept in his bed, even when he had four at the same time. 'It was like this gigantic nest. One above my head, one above my wife's, and two under the covers, on my side and hers. We were sort of sandwiched between layers of fur.'

Most, but not all, became his models. 'Some of them couldn't have cared less; the ones I have now [Flo and Topper] compete to be chosen, so I have to put the other one just outside the frame so they think they're part of it. Some I could put hats on, others didn't like them; some I could get to lie down, others had to be up on things. One of them was addicted to the strobe light. They all had different quirks that I really enjoyed finding out about.'

Of all his dogs, Penny was the best behaved. 'I never had to raise my voice with her. Two of the dogs – they shall remain nameless – have really enjoyed making me mad. What was worse was that they didn't even run away when I did. They'd just stand there, all blasé, as if they were saying, "Yes, I'm bad, look at me." And yes, I know that kind of anthropomorphism is really wrong, and even a little annoying, but it's really irresistible, too.'

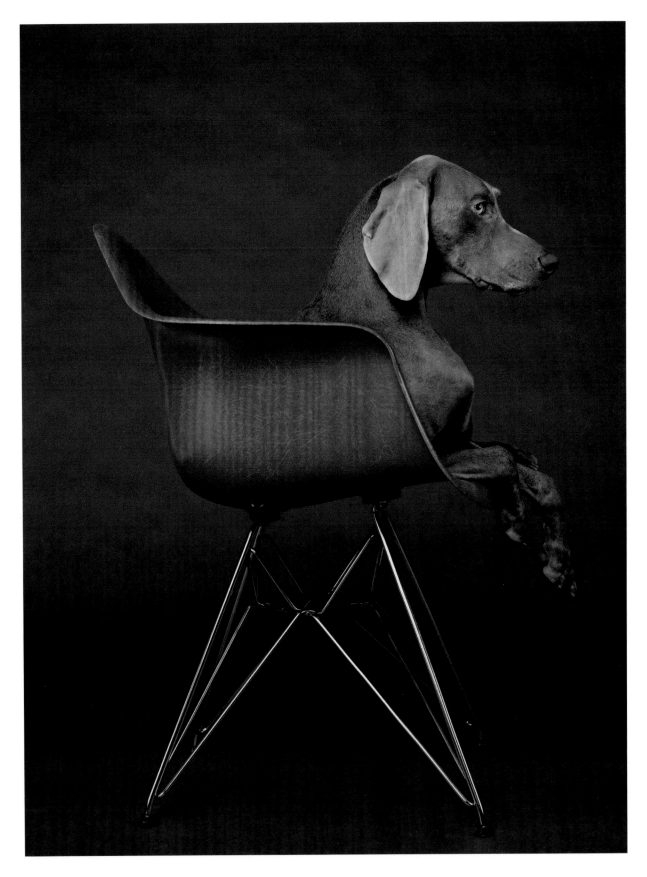

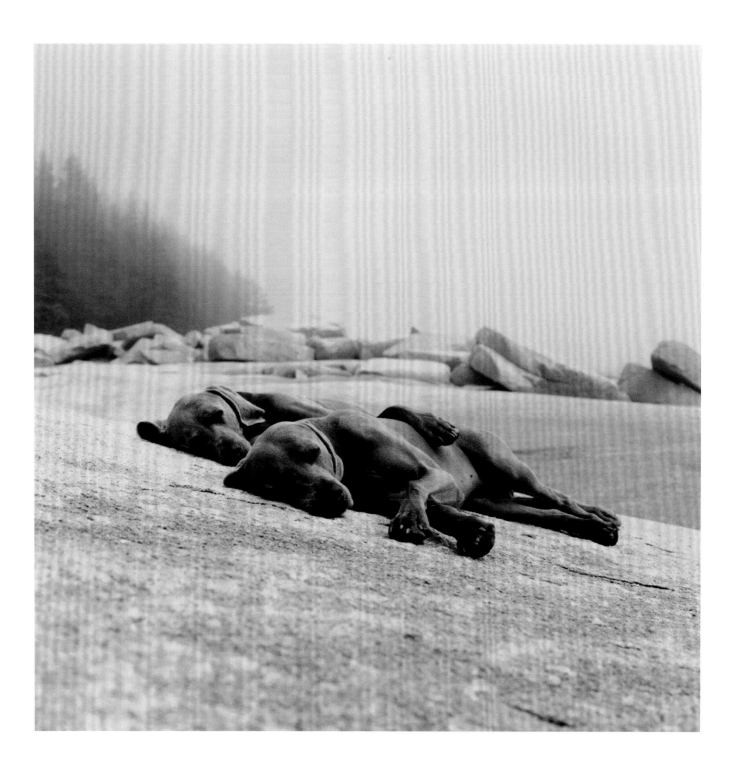

WASHED UP, 2002

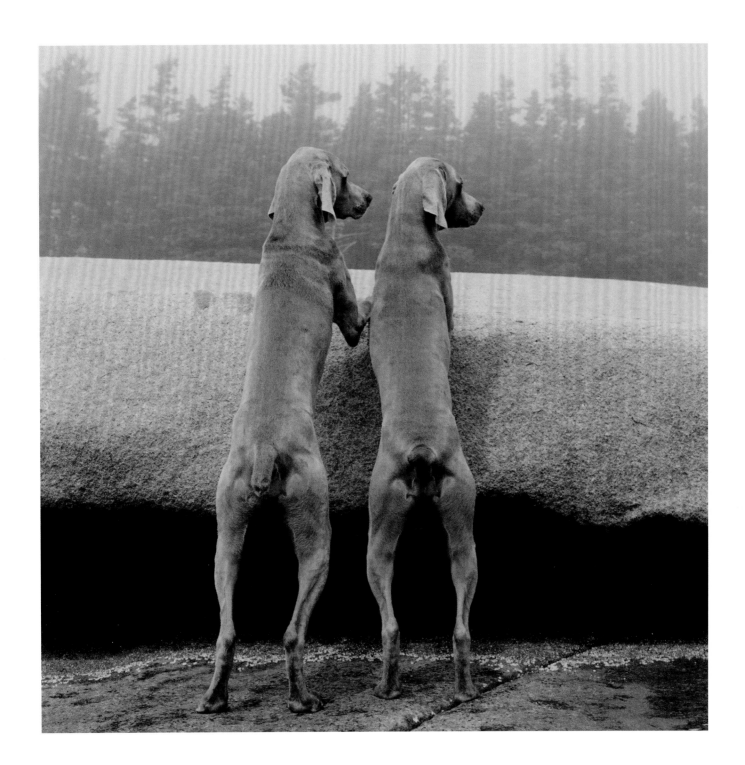

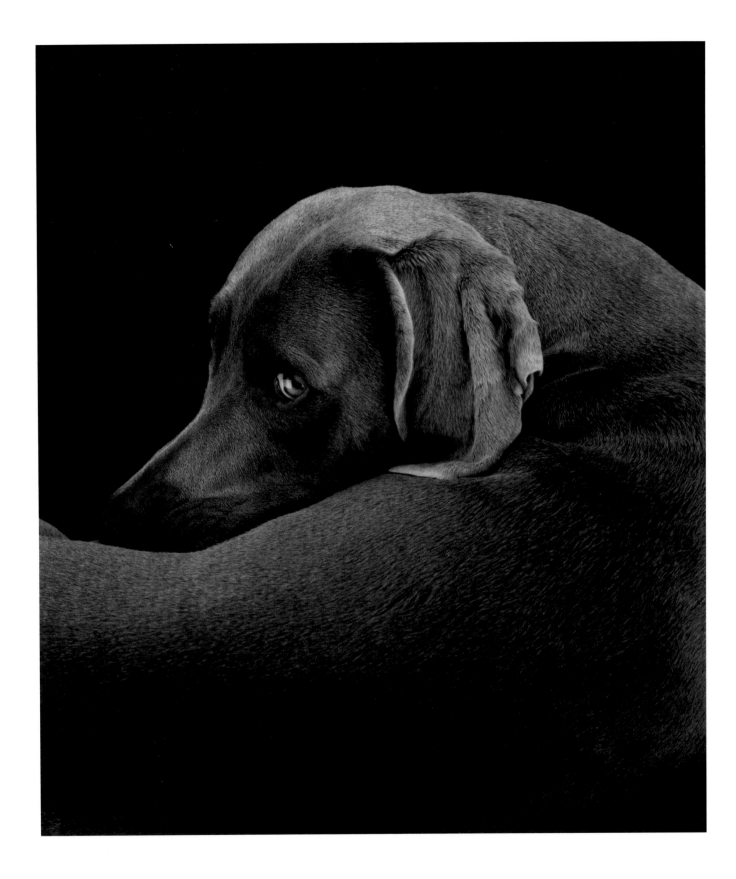

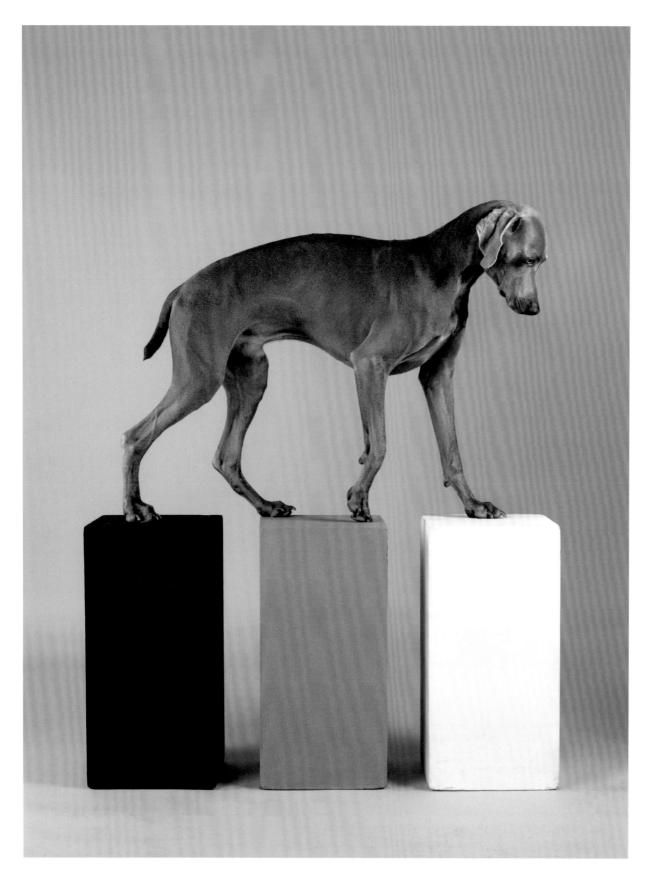

CONTACT, 2014

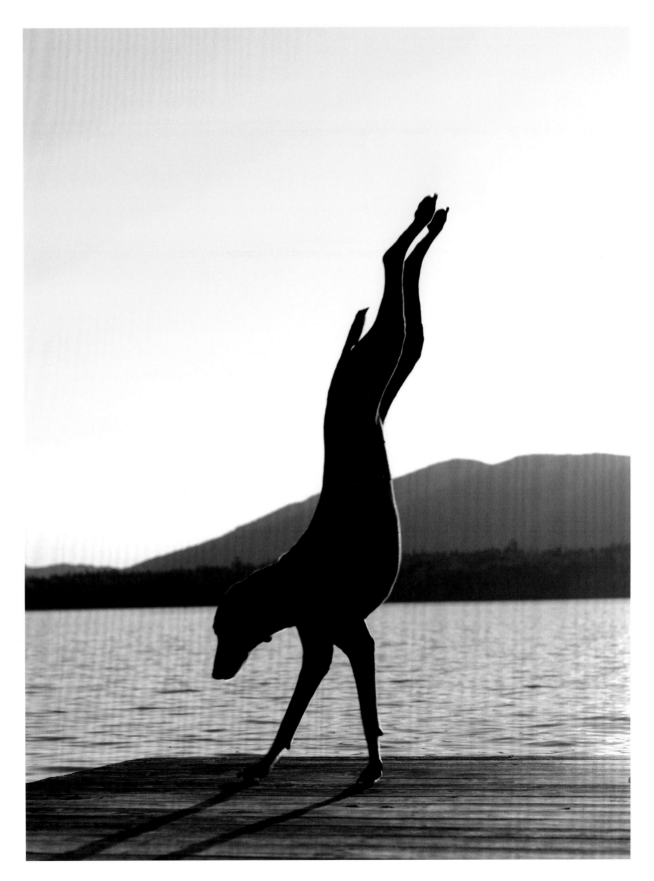

SHOW OF SHADOW, 2003

Traer Scott

HARROWING YET WARM-HEARTED PORTRAITS
RESTORE DIGNITY TO STREET AND SHELTER DOGS

'When the shelter filled up it was panic time. We would try to have the dogs fostered, but eventually we would lose dogs – good dogs.'

Given the choice between a human and a dog, Traer Scott would always pick the dog. 'When I'm with a dog I never feel alone, but I don't have the psychological baggage that comes with every single human being,' she says. 'Instead, I have this selfless creature that shows me completely pure, honest love.'

Dogs have always been a fixation. Aged seven, she learned the name and chief characteristics of every recognized breed. As a teen, she was obsessed with dog shows. But it wasn't until her twenties that she became aware of the huge number of homeless animals in North America and adopted the first of a series of rescue dogs, each of whom became part of her family.

In 2004, while working for a magazine in Rhode Island, she was sent on an assignment to an animal shelter. 'I saw immediately their need for volunteers who really cared about animals, and I signed up,' she recalls. 'Every day I was there for hours, just making sure the dogs got out of their cages. If we didn't come, they were confined all day and they would go crazy, because no creature can stand that. It became a huge part of my life.'

The American Society for the Prevention of Cruelty to Animals (ASPCA) estimates that around 3.3 million dogs enter animal shelters in North America every year, either as strays, or because they have been seized by police, or because they have been relinquished by their owners. About 35 per cent of these will find a new home, 25 per cent will be returned to their owners, but the rest have to be put to sleep.

'By law, the city pound has to take in any stray,' explains Scott, 'so when the shelter filled up it was panic time. We would try to have the dogs fostered, but eventually we would lose dogs – good dogs.'

The crunch came when she and her colleagues were unsuccessful in saving Riley, a pit bull/Rhodesian ridgeback cross. 'We fought so hard for him. It was crushing. I knew I needed to do something to memorialize him and the dogs we had lost. I needed people to connect with them and know that they had had a name, and that they were no longer.'

As a fine-art photographer, part of her duties at the shelter had involved making brightly coloured, cheerful snaps of the dogs for Petfinder, a website which matches homeless dogs with potential new owners. Soon, Scott began to experiment, turning a close-up into black and white and removing the background. 'I was amazed,' she recalls. 'I started looking at these images as true portraits.'

The photographs she took that year became the book *Shelter Dogs*. Published in 2006 and featuring fifty dogs, it sold like wildfire and launched Scott's career. Since then, she has returned to the subject with *Finding Home*, which followed the dogs into their new families, and *Street Dogs*, for which she spent several months in Mexico and Puerto Rico. Shot on the hoof, against make-do and often grubby backgrounds, the street portraits in particular, of once abandoned and often abused dogs, call to mind photographs of frayed and wounded veterans from the American Civil War.

Photographing the shelter and street dogs confirmed 'something that I think I already knew but I hadn't seen in practice – the true capacity of these animals to love and trust, despite having had horrible things happen to them,' says Scott. 'I was constantly amazed by the emotion I found there.'

STREET DOGS, GUMDROP, PUERTO RICO, 2007

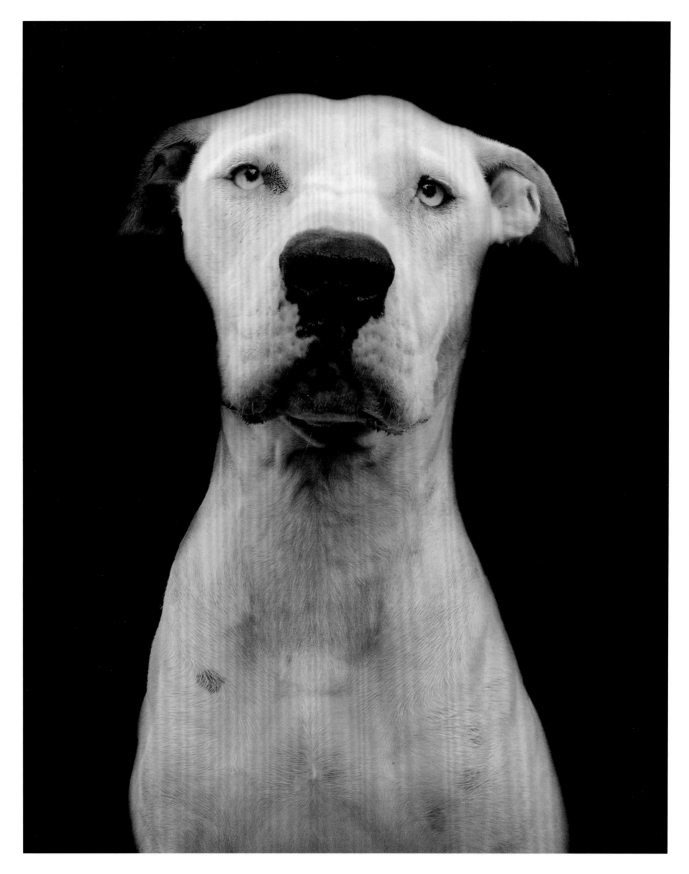

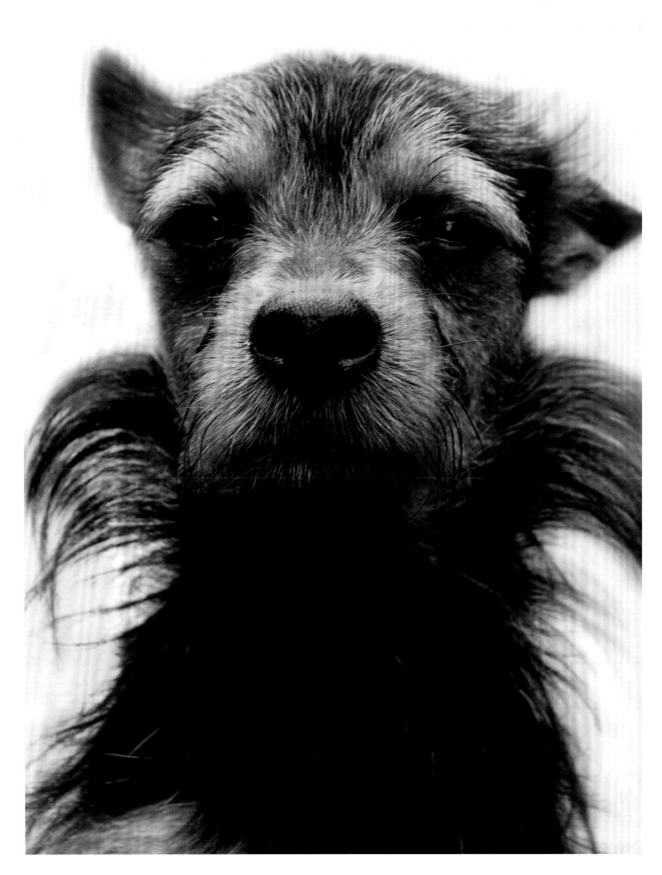

SHELTER DOGS, TERRIER (ADOPTED), 2005

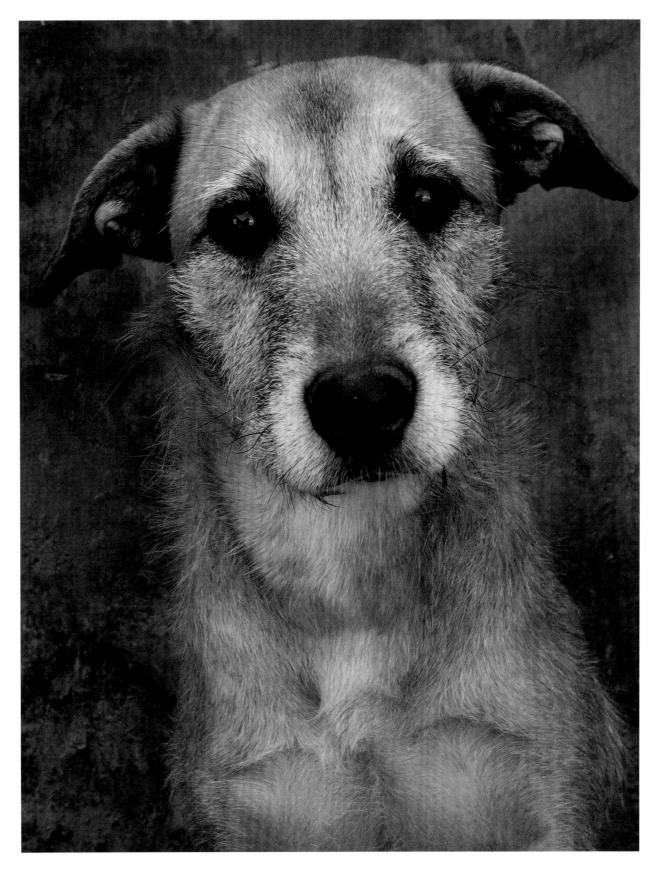

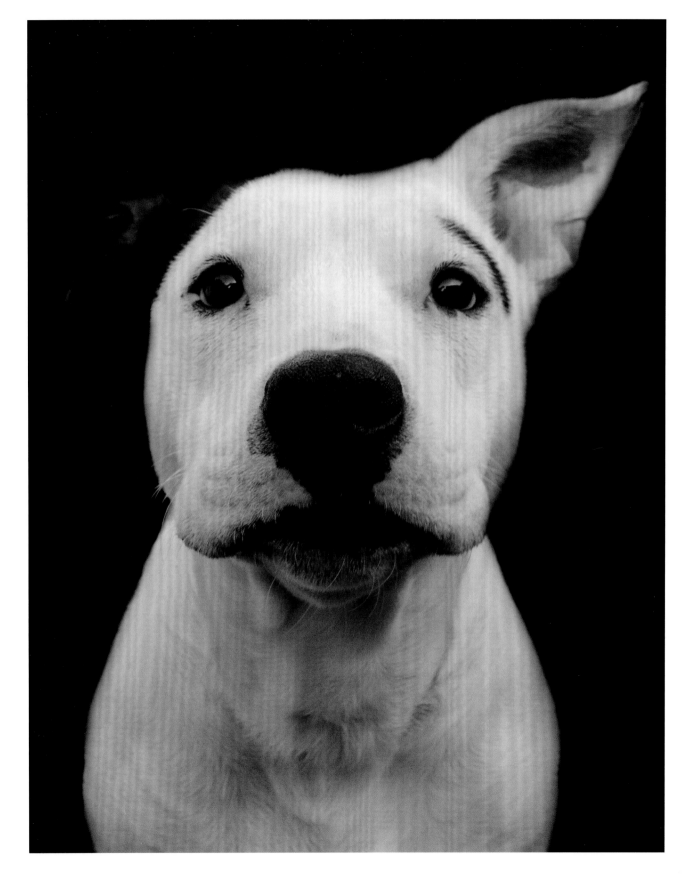

Alec Soth

STRAY DOGS ROAMING COLOMBIA'S CAPITAL
CITY HINT AT THE HOPES AND FEARS OF
IMPENDING FATHERHOOD

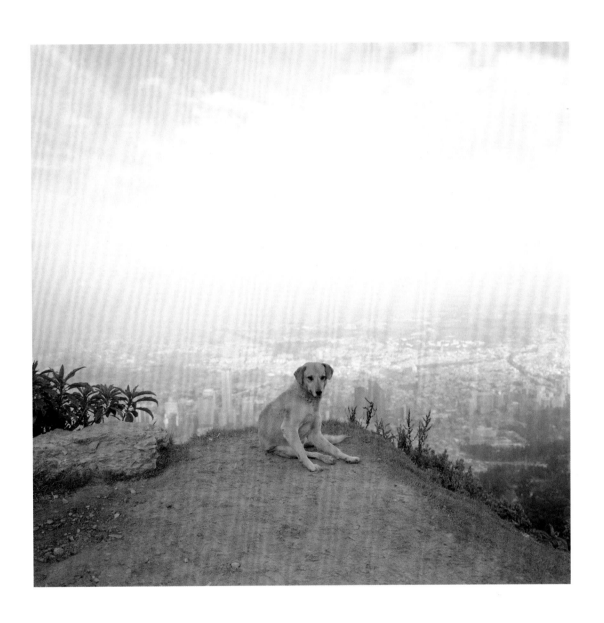

Followers of his Instagram account will know that Alec Soth has a special relationship with Misha, the labradoodle who has been part of his Minnesota-based family for nearly eight years. He photographs her in sports kit, Halloween masks, perched on snowballs and kettlebells and playing table tennis. 'She's extremely mellow,' he says, almost unnecessarily.

It's quite a departure from his usual fare. Soth is the photographer behind *Sleeping by the Mississippi*, a mournful yet enchanting study of riverine America, made in 2004. Its impressionistic structure was like nothing the art world had seen before, and it has left legions of fledgling photographers swimming in his wake.

Dog Days, Bogotá is also atypical of his oeuvre, though in a different way. 'I normally work in America; I normally work on projects for years rather than weeks' he says, 'but when I made this, I didn't know it was going to be anything. I was just doing it intuitively.'

He created the series during a two-month period when he and his wife were waiting to adopt their Colombian daughter, Carmen, in Bogotá. Photographing was, he admits, 'a way out' of the strange situation he found himself in.

'I would say, over and over again, I don't know this place … and I didn't know I was going to be there that long – it was the paperwork – but my daughter's birth mother had made her a book of letters, pictures and poems, which inspired me to make a book of my own for her, about the place she was born. It turned into something much bigger.'

Of the forty-nine photographs in the sequence, ten feature dogs, mostly strays and street dogs, of which there are an estimated 90,000 in the city at any one time, according to Colombia's health department. 'It's impossible not to notice them,' says Soth.

But though the spectacle of Bogotá's canine legions has its own thread to contribute to Soth's impression of the city, their repeated appearances also act as a refrain in the run of images. As well as this, the dogs are an important metaphor. 'I kept seeing these street children,' explains Soth, 'and thinking about them in relation to my daughter, but I felt uncomfortable photographing them and so, in some ways, the dogs became a stand-in.'

Soth was using the title of the series – *Dog Days, Bogotá* – 'über-literally but also for the connotations of the term, meaning a period of waiting, in the summer heat. But I regret it, too, because it also has negative undertones, and they weren't bad days at all.' Instead, his experience there persuaded him of the 'companionship of animals' and 'the perseverance of the human spirit'.

He returned often to a pilgrimage site located high above Bogotá – the picture of the dog on the rocky outcrop with the city spread out behind him and turned ghostly in the bright sunshine, was taken there. 'There's just something regal and magnificent about that dog that I wanted to spotlight,' he explains. 'For me, that's one of the qualities of photography: to take something humble and ennoble it.'

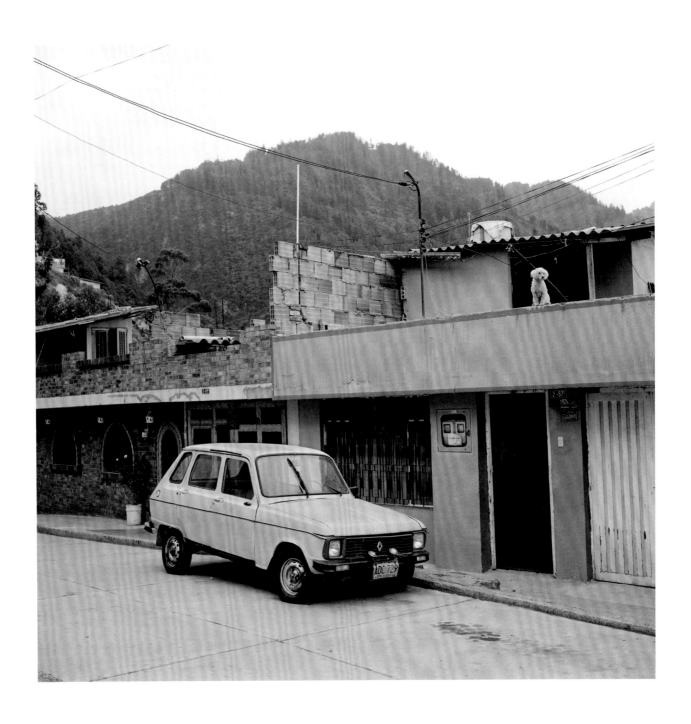

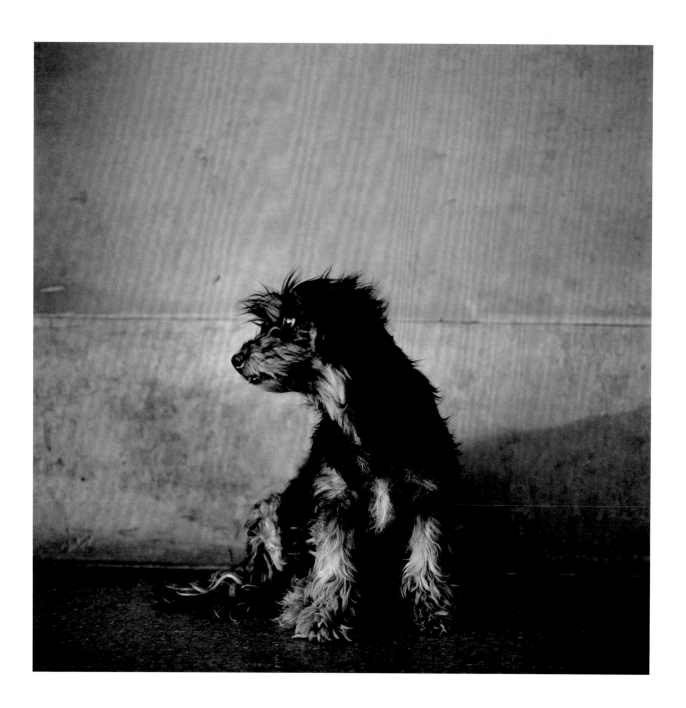

DOG DAYS, BOGOTÁ, COLOMBIA, 2003

Raymond Meeks & Adrianna Ault

QUIET, THOUGHTFUL PORTRAITS OF THE DOGS
CONFINED IN NEW ORLEANS'S ANIMAL SHELTERS

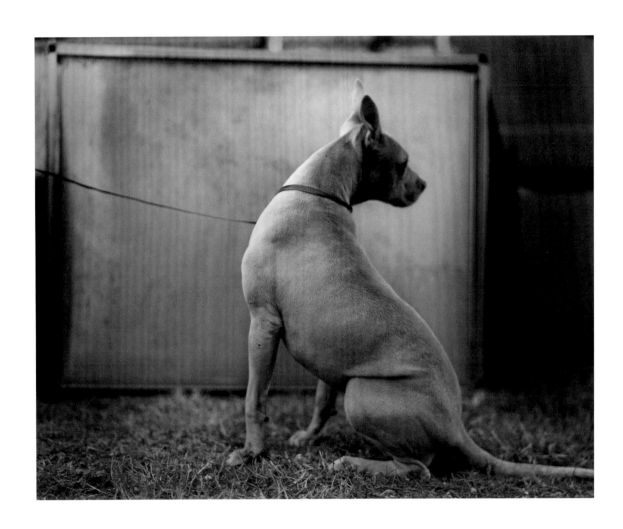

Adrianna Ault grew up in New Orleans. Her stepfather was director of one
of the city's animal shelters, on Japonica Street. Most days she went with him
to work, where, in among the cinder-block kennels filled with the robust
odours of bleach and urine, she formed a 'deep, compassionate regard' for all
animals, but especially the dogs.

Last year, now a parent herself, Ault returned to New Orleans. Her
partner Raymond Meeks came too. Both are artist-photographers – Meeks is
revered for his one-of-a-kind, hand-bound books – and both have 'pretty
charged feelings concerning companion animals,' says Meeks, 'so we wanted
to follow up on that impulse. At that stage we weren't sure what form our
work would take, but Addie had wanted to reconnect with the city and
revisiting the shelters was part of that.'

New Orleans has long struggled with its population of strays. In 1991,
the *LA Times* reported 'literally tens of thousands of animals running loose …
a city of half a million people with virtually no animal control'. Hurricane
Katrina aggravated the issue when, following the emergency evacuation, some
600,000 animals were left to fend for themselves.

Because Japonica Street is adjacent to the city's many canals, almost all of
which broke their levees and flood defences, the animal refuge at which Ault's
stepfather worked no longer existed. Instead, she and Meeks visited four of
the remaining shelters.

Though these facilities housed a variety of animals, the couple, who met
just over three years ago and live in New York, decided to focus on dogs. It's
an animal they share 'an affinity' for, says Meeks, who, since his own German
shepherd passed away, has shared Ault's border collie, Brees, named for the
quarter back of the New Orleans Saints football team.

Over the course of five days they used a range of medium- and large-
format film cameras to photograph the dogs (they also took a digital picture
of each, for the shelter's use), taking it in turns to be the one clicking the
shutter, and the one attending to the dog.

'We spent between ten and fifteen minutes with each dog,' says Meeks,
'and most of that was simply exercising the animal; giving him a walk or
a run-around, whatever he needed. Our philosophy was to give before we
asked, so we gave our time and our attention, hoping that we might establish
some sort of rapport.'

Though they tried to compose the space, carefully selecting the environ-
ments for their calm feel, light levels and potential for an interesting backdrop,
each and every time the dogs brought their own energy to the situation.
'Everything we had planned would go out the door,' Meeks says. 'In the end
we had to compromise between what we had chosen and where the animal
decided to go. But it's always good when that happens – refreshing. I tire
easily of seeing my hand in something. I want that collaboration'.

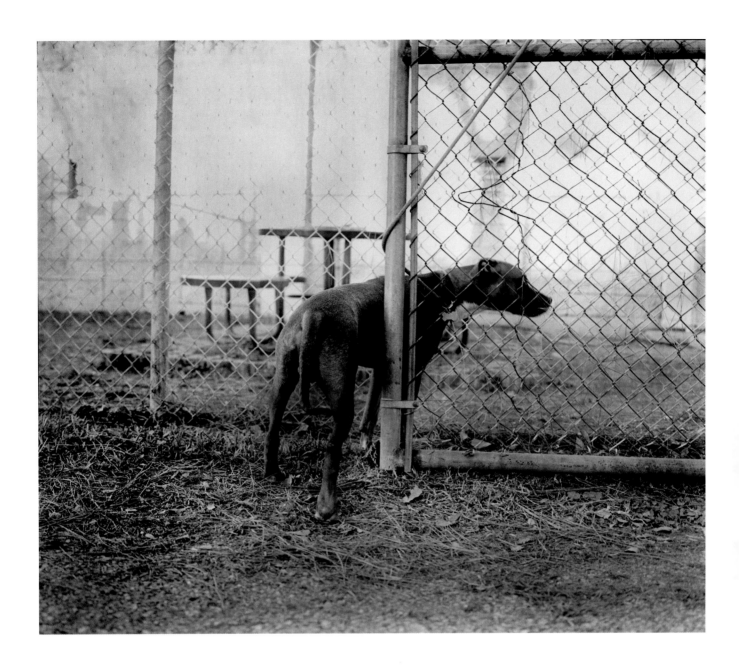

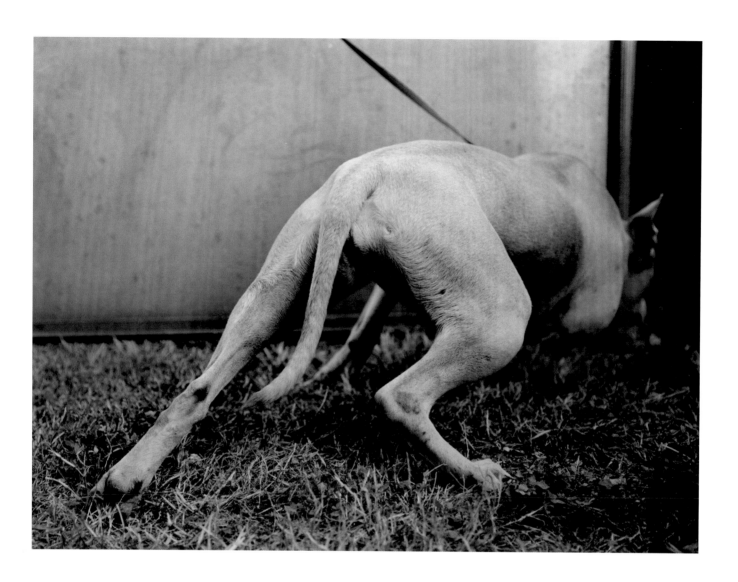

MARRERO #247, NEW ORLEANS PARISH, LOUISIANA, 2014

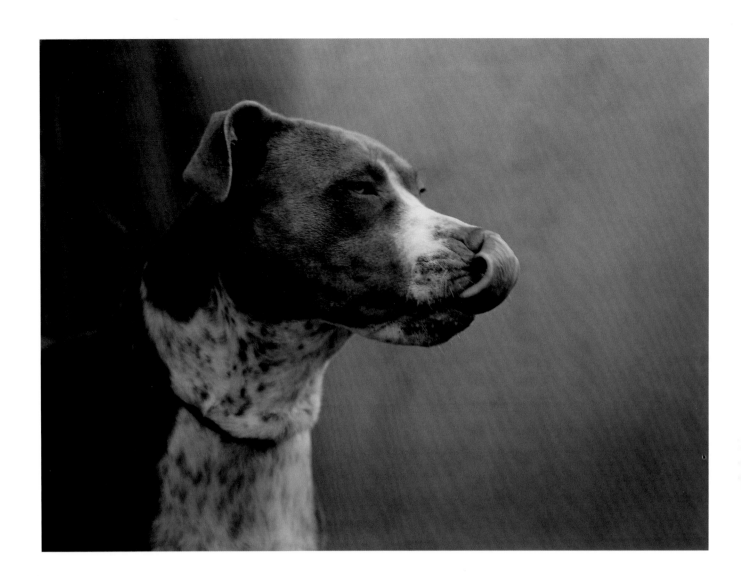

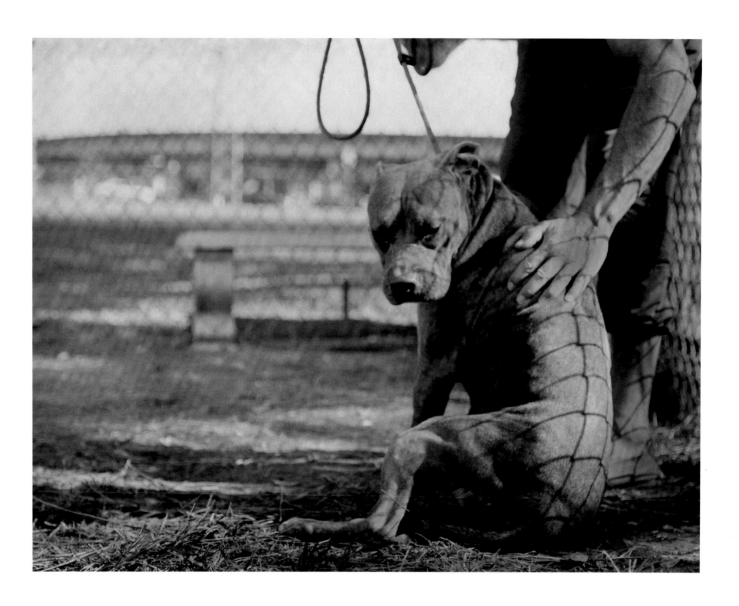

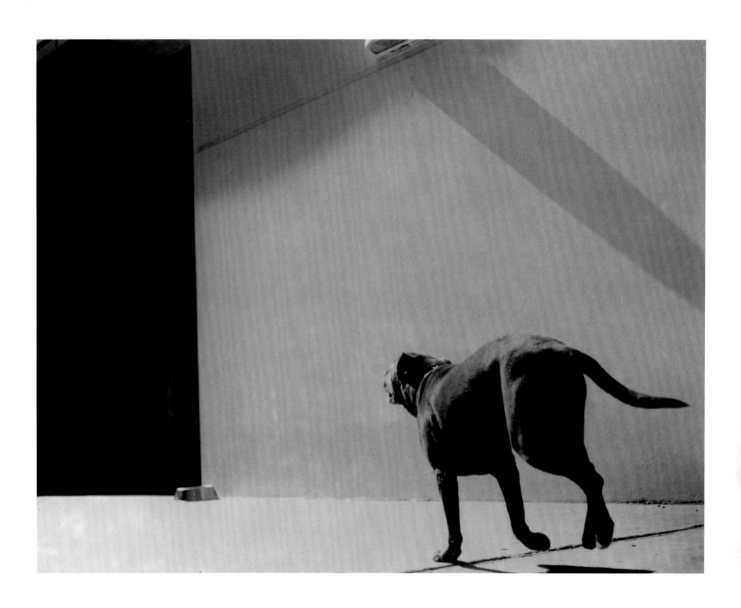

Landon Nordeman

THE WEIRD AND WONDERFUL
WORLD OF DOG SHOWS

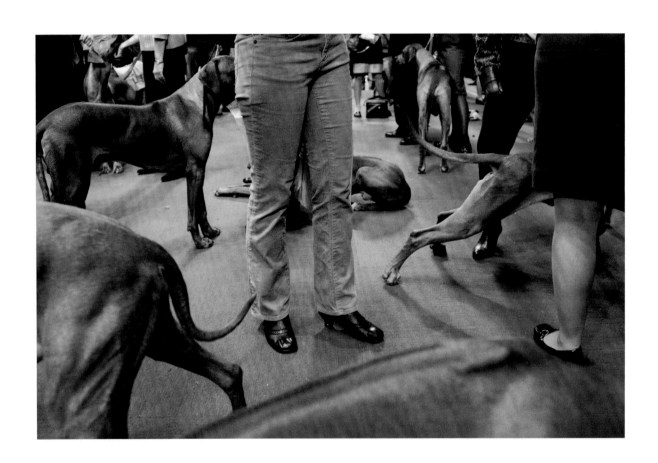

‘It's a true spectacle, the granddaddy of dog shows ... history, combined with expectation, competition, ritual and ceremony’

Every February, nearly three thousand pedigree dogs descend on the city of New York for the Westminster Kennel Club Dog Show.

Founded in 1877, the event has real cachet. Previous entrants include dogs bred by General Custer (in 1877), Tsar Alexander III (in 1889), the philanthropist and banker J. P. Morgan (in 1893) and the intrepid journalist Nellie Bly (in 1894).

Today, the show has become a true sporting event, on a par with the Super Bowl or the World Series. Even though it's broadcast live on national television, thousands of spectators pay around $40 a ticket to watch the show live at Madison Square Garden, where they can munch on hot dogs and popcorn, and cheer for their favourite four-legged competitor on the famous green carpet.

And, because many of the owners, handlers and breeders come to New York from all over the country, the entire city tends to go a little dog crazy. There are brunches and cocktail parties and fashion shows, exhibitions and dinners, all with a doggy theme. All of which absolutely enchanted photographer Landon Nordeman when he was sent to cover the show for his agency in 2004.

‘It's a true spectacle,’ says Nordeman, ‘the granddaddy of dog shows ... history, combined with expectation, competition, ritual and ceremony’. A friend who spotted him working there described the expression on Nordeman's face as one of ‘ferocious glee’.

Nordeman's camera lens is more usually turned toward spectacles of a human kind, chiefly the worlds of fashion and politics, which he photographs for publications such as the *New York Times*, *Vanity Fair* and *National Geographic*. Nevertheless, he was able to apply the same ‘open heart, open mind’ approach that has always stood him in good stead, hunting out the things that happen on the edges of the spectacle, rather than at the centre of the action. ‘I am attracted to moments that surprise me, whether because of their humour, or colour, or juxtaposition,’ he explains. Westminster is a gold mine for this kind of unexpected, humdinger detail, he says, ‘because dogs are so unpredictable’.

Since then, Nordeman, who grew up with a Tibetan terrier named Potatoes, has followed the dog-show trail to cities such as Paris, Bucharest and Helsinki. Passionate, dedicated owners were a given, but he never failed to be surprised by the camaraderie of the dog show world. ‘I was amazed to learn about people who grew up competing as junior handlers, and then went on to own dogs, breed dogs, judge dogs. When you scratch the surface, you realize how deep it goes’.

In 2011, he was granted permission to accompany Westminster's Best in Show winner – Hickory, a Scottish deerhound – on the dog's press tour around New York. As well as a visit to the floor of the city's Stock Exchange and to the top of the Empire State Building, the victory lap included Trump Tower. ‘Little did I know that I'd be shaking hands with the future President of the United States,’ says Nordeman. ‘And the story is better than the photograph, or else you'd be looking at a picture, not reading these words.’

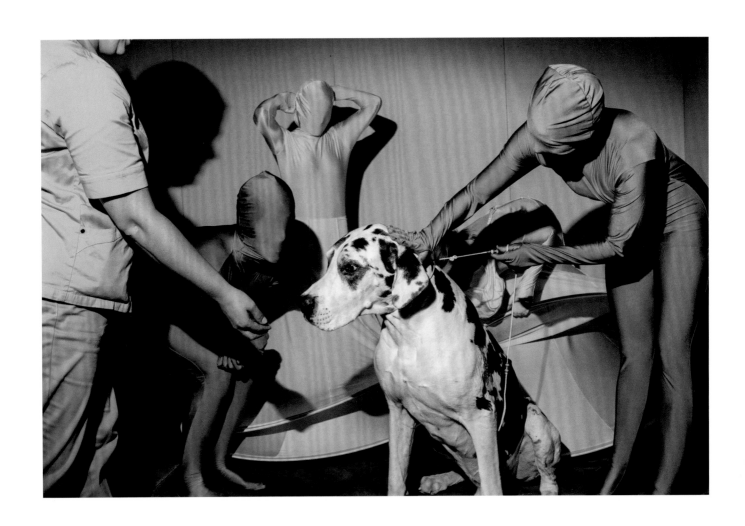

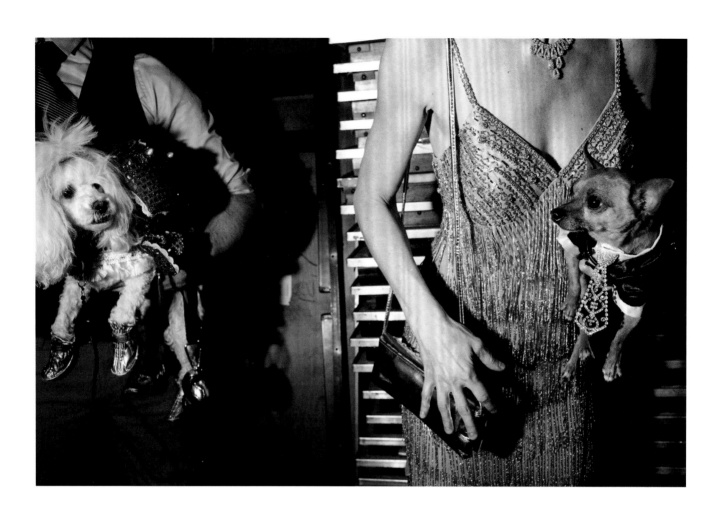

CANINE KINGDOM, DOGGY FASHION SHOW AT
THE PENNSYLVANIA HOTEL. NEW YORK CITY, 2012

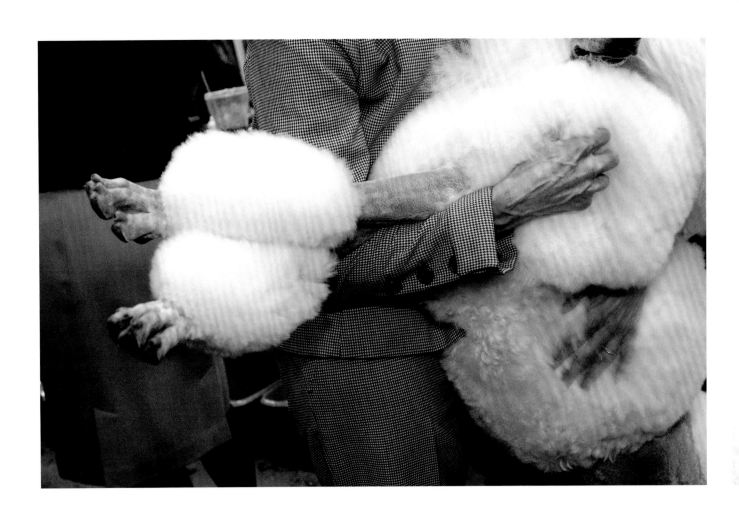

Tim Edgar

THE CURLICUE, SPATTER-LIKE AND LINEAR
TRACES LEFT BY URINATING DOGS FORM
A CURIOUS URBAN ANTHOLOGY

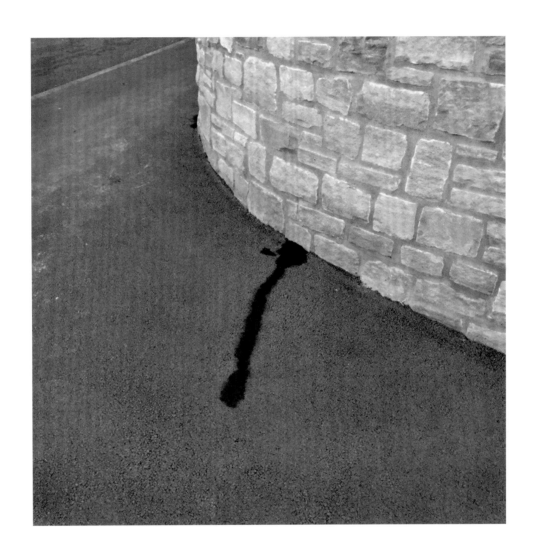

'I think of the dogs as mark-making, just as an artist does with his brush, or a sculptor with his tool... Yes, it's a bit random, but so were the paintings of Jackson Pollock.'

It began as whimsy: one impulsive photo of a curious wet squiggle on the tarmac taken with an iPhone. But a year later, Tim Edgar's anthology of dog wees has turned into a serious creative pursuit.

'I think of the dogs as mark-making, just as an artist does with his brush, or a sculptor with his tool,' says Edgar, whose urinary *Wunderkammer* now numbers in the hundreds, with examples from all over his hometown of Swanage, Dorset, as well as neighbouring Poole and Bournemouth and, latterly, London. 'Yes, it's a bit random,' he admits, 'but so were the paintings of Jackson Pollock.'

Of particular appeal to Edgar is the way in which the wee interacts with the unique fabric of a particular landscape. The wall or stone it comes into contact with, together with the chemical make-up of the urine, can have quite an impact on both pattern and longevity. He loves, too, that each one is a transient one-off, never to be repeated – a type of performance art, if you like.

In fact, Edgar's series follows a grand tradition of artists who have incorporated urine into their work. Andy Warhol, for instance, invited friends to 'contribute' to a canvas coated with wet copper paint so that the acid in the urine would oxidize and change colour, creating abstract patterns. And Andres Serrano controversially submerged a crucifix into urine for his photograph 'Piss Christ', creating a scandal that went all the way to the White House.

Some of Edgar's pictures prompt the phenomenon known as pareidolia, where viewers see the shape of an animal or a face in their surroundings. The photographer Martin Parr, for example, who is a friend of Edgar's (the two were part of the same darkroom co-operative when Edgar lived in Bristol), suggested that one of the wees looks like a poodle.

If he's not sure whether a mark is urine or a spilt drink, Edgar, who teaches photography at the Arts University Bournemouth, will enlist the help of his own dogs, two terriers named Figgy and Biba. He hasn't photographed their wee, though, 'because there's something not quite right about that'.

The pavement also provides Edgar with fodder for his other creative enterprise: collecting bits of discarded text, such as letters and lists. He cleans, categorizes and photographs each one, posting them on Instagram, before filing them away carefully in folders at home.

Edgar's penchant for detritus he discovers on the ground comes – he thinks – from a childhood interest in natural history. His older sister worked at a vet's and would often bring sick birds home. He remembers picking apart owl pellets – the undigested remains of prey, such as bones and teeth, which are ejected through the mouth – to see what the birds had eaten.

As the dog-wee series has progressed, Edgar has found several interesting subsets – one particular post which is very popular with the dogs in Swanage, for example, and instances of the urine bleaching the wall. Still on his hit list is a double wee. 'I've had this fantasy image,' he says. 'The one I'm waiting for. It's where there is one wee fading and a stronger, fresher one over the top, like a layering. I'll find it one day.'

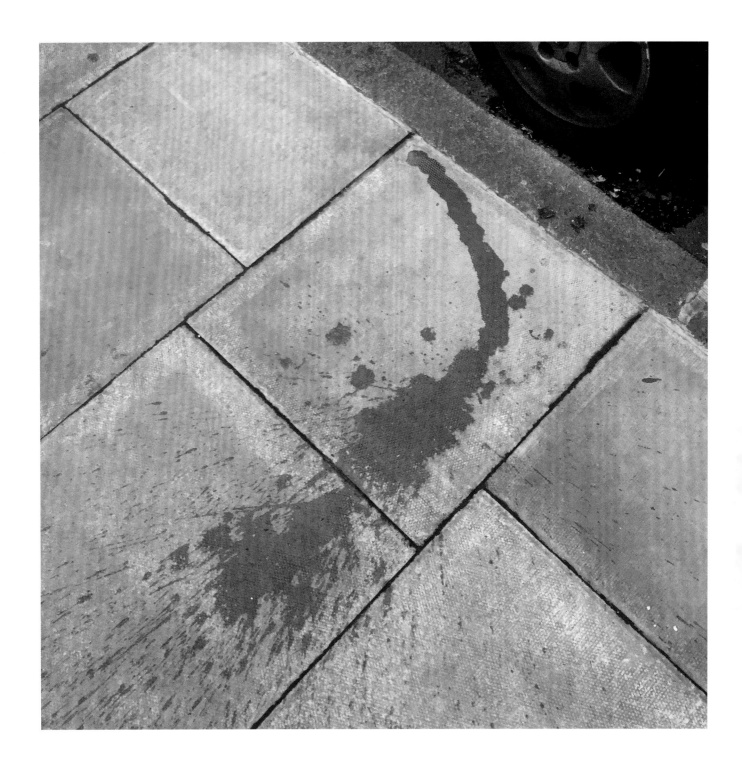

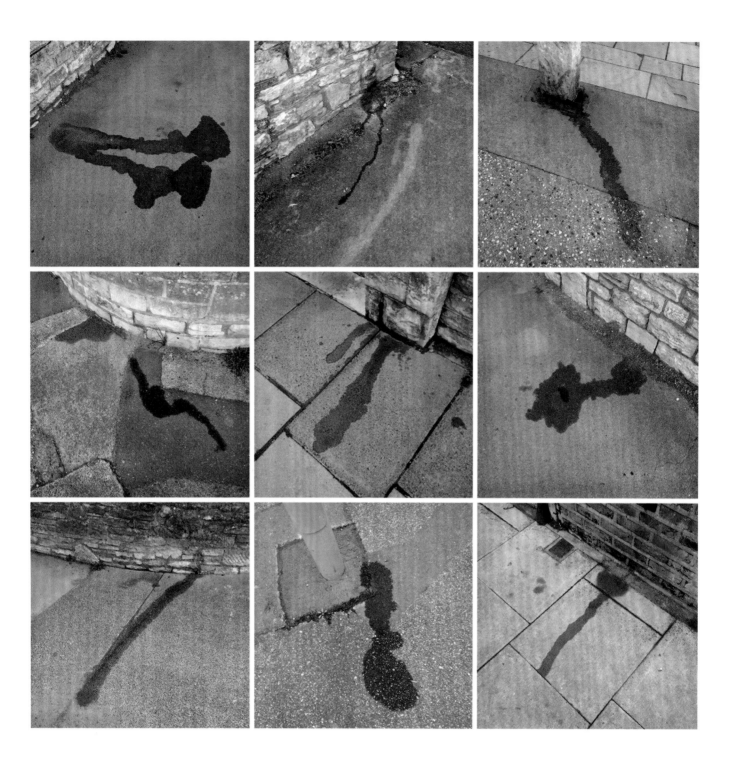

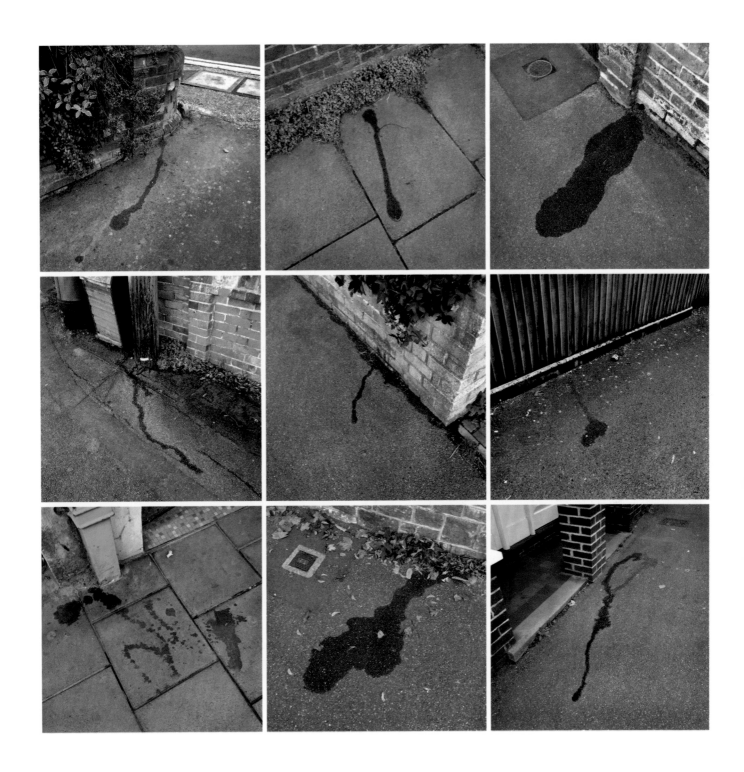

Sophie Gamand

NO TRIP TO THE GROOMERS IS COMPLETE WITHOUT
A BATH - MUCH TO THE HORROR OF THESE DOGS

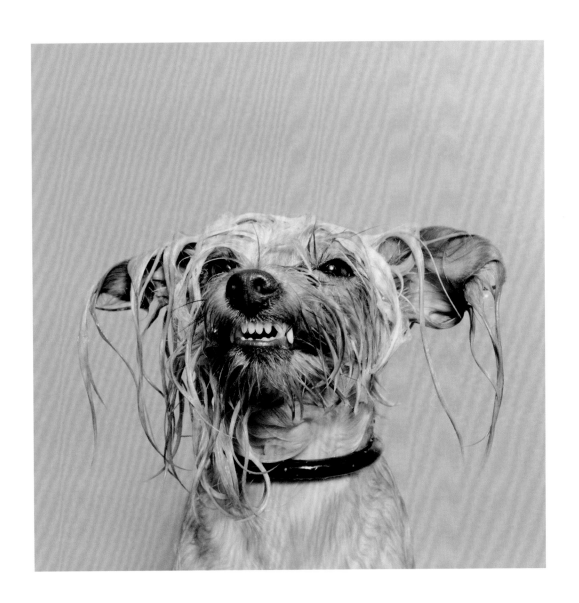

'For a lot of dogs, being bathed is a bit overwhelming. In that moment, they're so vulnerable, but they still trust us.'

It took a move to New York for Sophie Gamand to nose out her canine calling. 'I was shy, and everything was new and slightly scary. Taking pictures of dogs became my way in – a less threatening, less direct way of engaging with people,' she says.

Back in her native France, photography had been just a hobby, but a new start came with the opportunity to try something different. Having grown up with a pair of German short-haired pointer sisters named Arpège and Ardoise, Gamand enjoyed a strong bond with dogs. For a time, she volunteered for a dog-rescue organization that wanted pictures for their adoption programme, but by 2013, three years after she had settled in America, her bank account was near zero.

She made the decision to have one final push and set herself the task of shooting one project a day for a week. Researching all the things New Yorkers do with, and to, their dogs, she discovered some had their own Facebook pages and busier agendas than her own. Others were dressed in couture and taken for walks in a baby's pushchair. A few were on antidepressants.

Her first project, though, was at a dog-grooming parlour in the Bronx where her friend Ruben Santana, a pet stylist with a purple poodle named Dana, worked. Gamand went in, thinking she would make a sequence of before-and-after pictures, but when Santana dunked one of the dogs in a tub she realized she had struck gold. 'At first I was fascinated by the way the water played with their fur,' says Gamand, but then she noticed the dogs' expressions – vulnerability, anger, revolt, submission. She snapped picture after picture. 'I went home that night absolutely exhausted.'

A few days later, she tentatively sent eight photos to a blog. The images went viral. Then, in the spring of 2014, she won first prize in the portrait category of the Sony World Photography Awards. 'It validated my intention to photograph dogs for their soul and their individual qualities,' she says, 'rather than for their animal characteristics. It changed my life.'

When Gamand worked at the shelter, she had always volunteered to bathe the dogs. 'For me, it was almost like a baptism, where the dog left behind the world of neglect and abuse and entered a world of caring and comfort. The bath can be such a strong bonding experience between dogs and humans. These pictures are partly a celebration of that.'

There are around eighty dogs in the final series, of every size and breed. 'I always tried to get the dogs' attention when I took their picture,' she says of her process. 'Partly because I liked eye contact in the photo, but also because, for a lot of dogs, being bathed is a bit overwhelming. In that moment, they're so vulnerable, but they still trust us. I was trying to be there for them, in a way.'

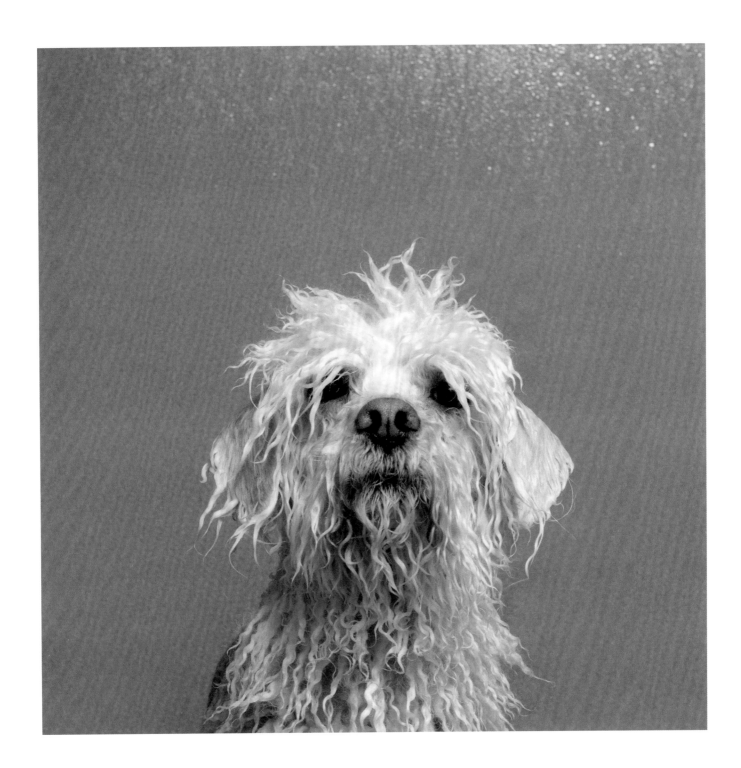

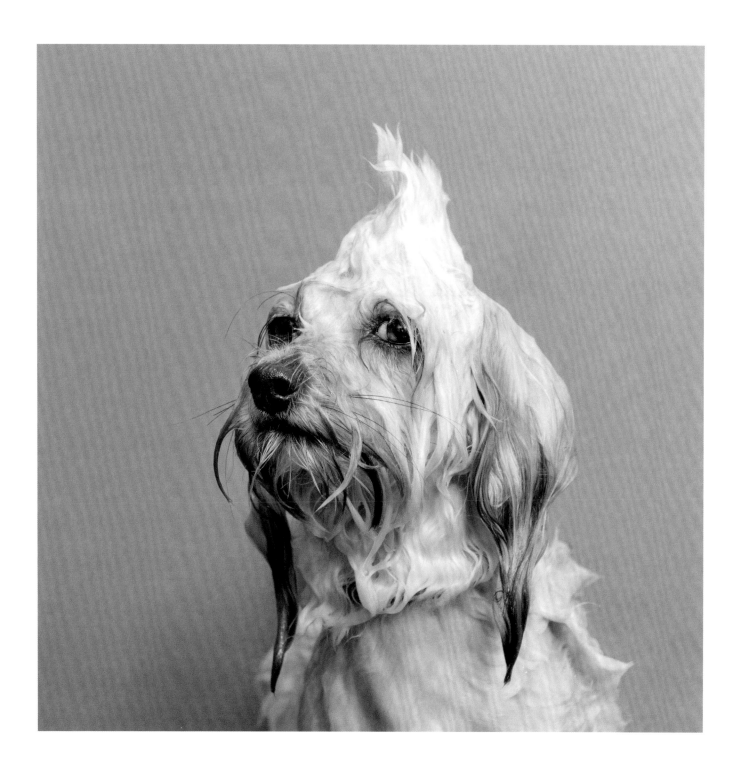

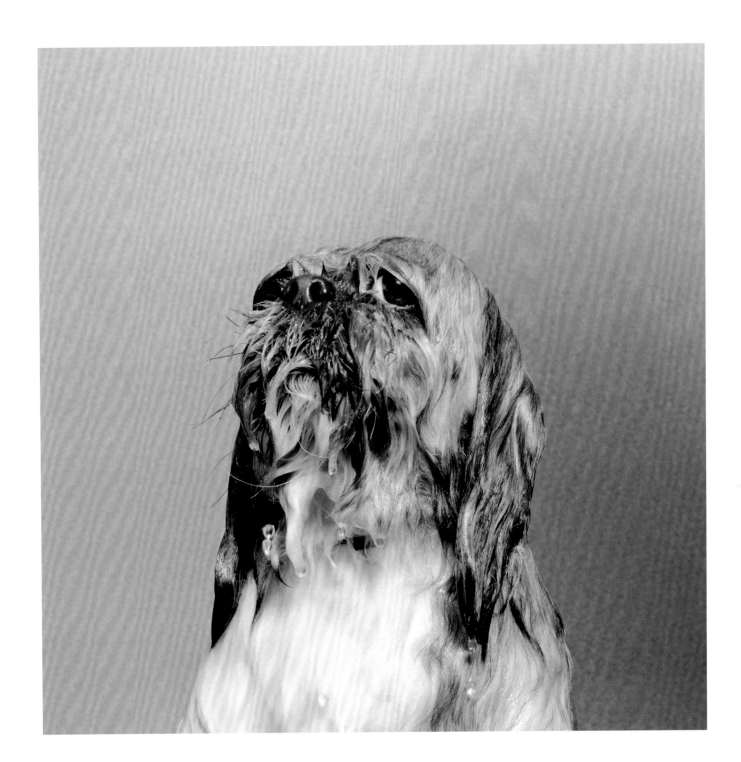

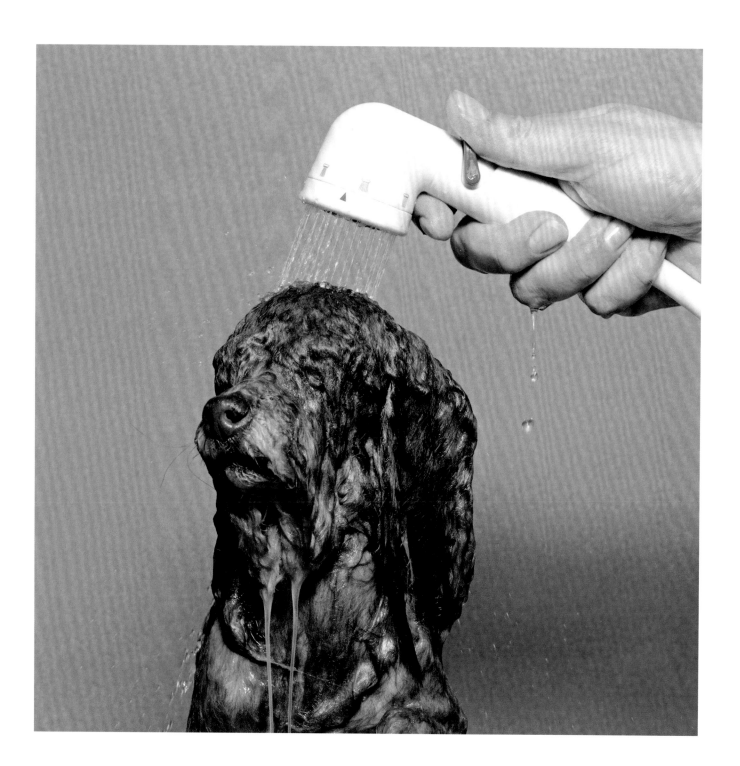

WET DOG, BRITNEY 2, 2014

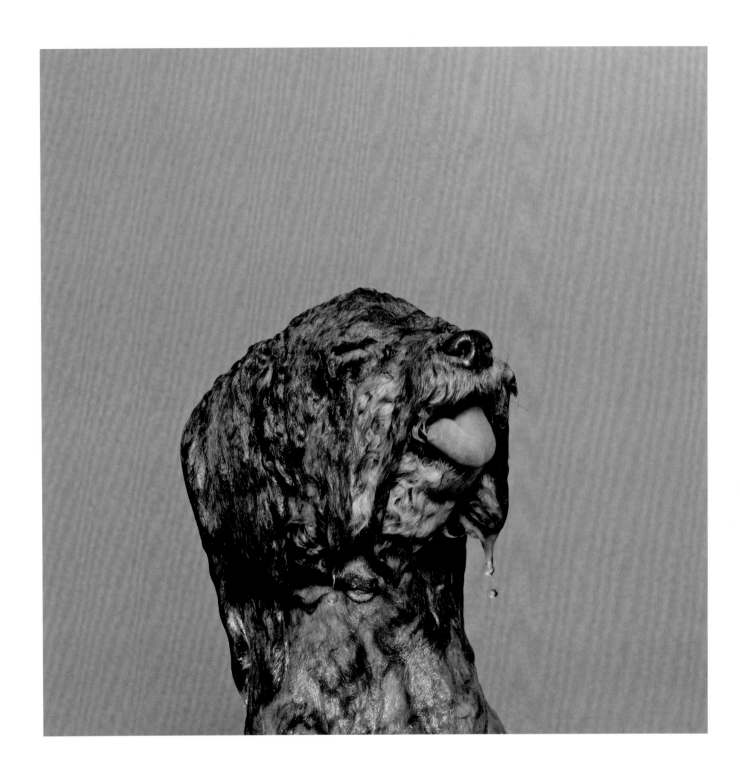

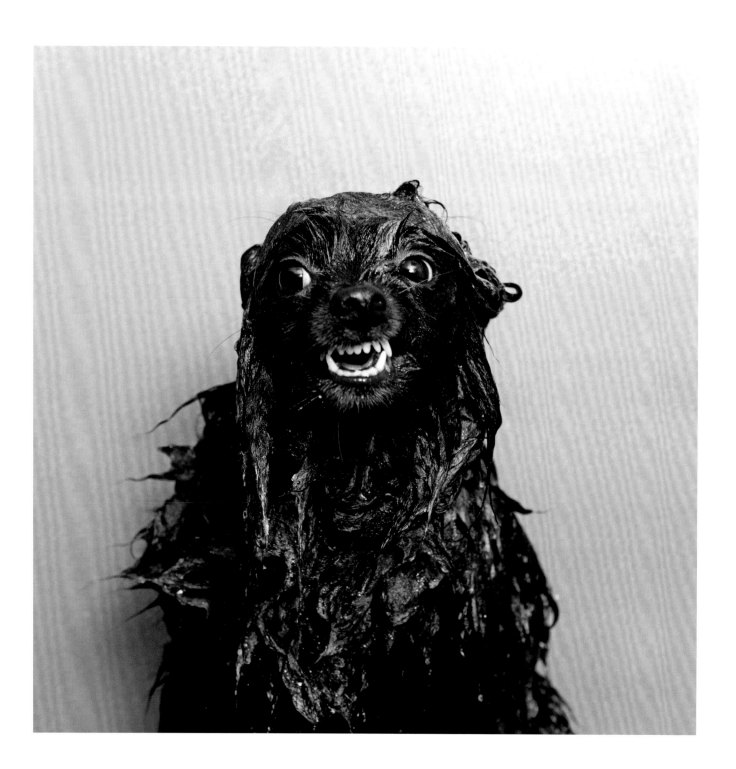

WET DOG, JOY 2, 2014

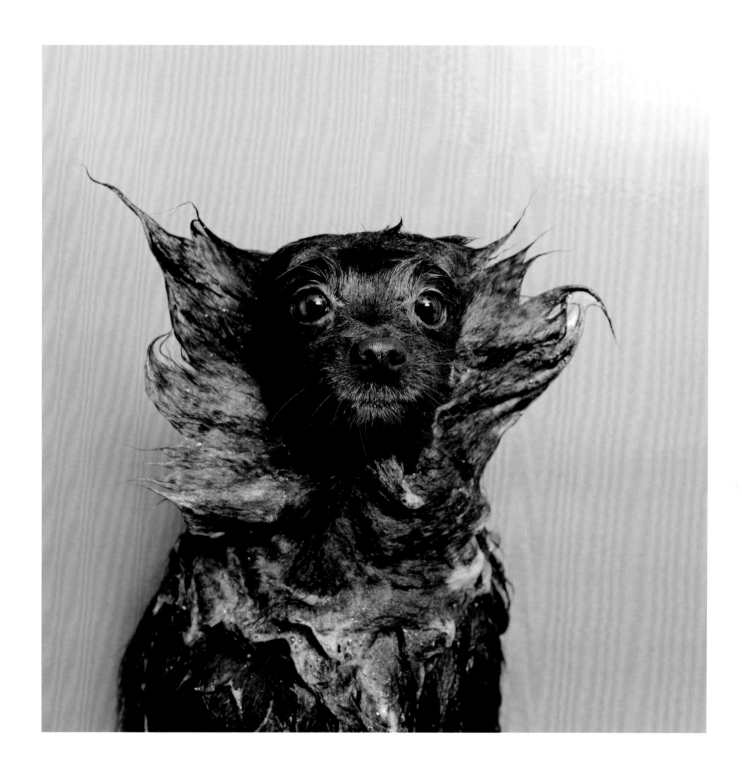

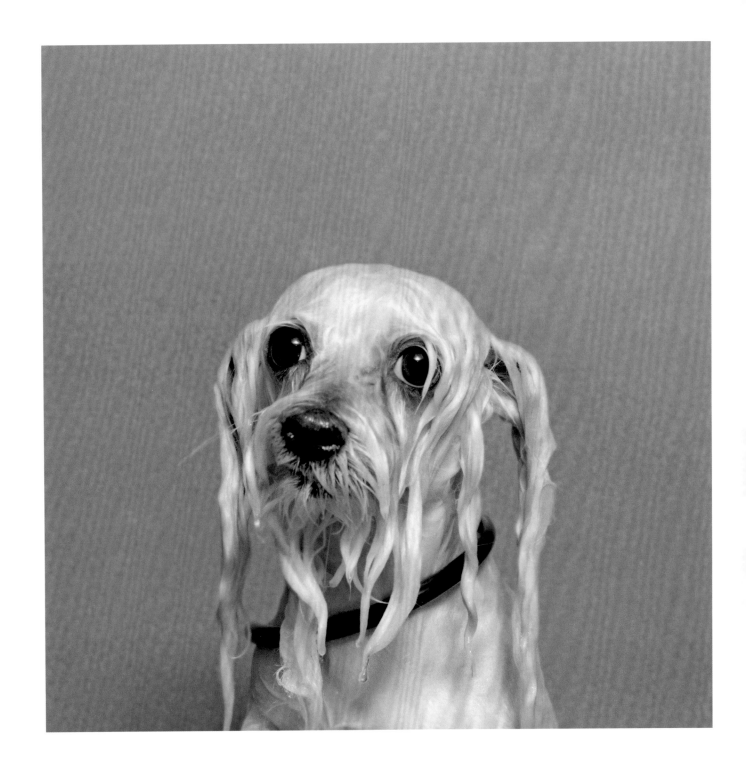

Daniel Naudé

CONFRONTING THE FERAL AFRICANIS DOGS ROAMING
THE DESERT PLAINS OF THE SOUTH AFRICAN KAROO

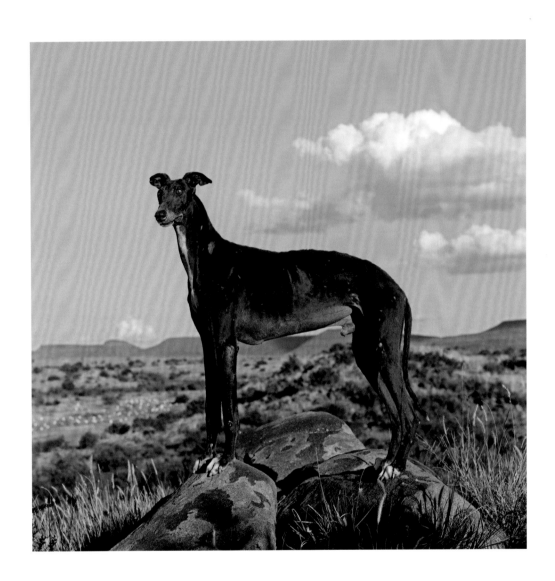

Driving from Cape Town to Mozambique, where he planned to go surfing, Daniel Naudé had to cross the Karoo, a sprawling expanse of semi-desert straddling South Africa's middle. On a lonely road about twenty-five miles from the nearest *dorp* (small town), a dog appeared unexpectedly by the side of the car.

'It was so skittish and feral – like something from a J. R. R. Tolkien novel,' recalls Naudé. 'I stopped the car and chased after it, and at one point it turned and gazed straight at me, with its tongue hanging out. Then it began to run, heading away from me, into the barren landscape. The whole encounter was so vivid, it shocked me.'

For the rest of their road trip, Naudé and his friend talked incessantly about the dog. 'I couldn't get over it, and I thought, This needs to be captured; I need to work out what it is that I am so addicted to in this experience and share it with the world.'

Back at home, Naudé read everything he could find about the wild dogs that roam all over the South African subcontinent. Named 'Africanis', they are a naturally crossbred race which has adapted slowly to the local landscape. Their ancestors date back to Neolithic times and appear in hieroglyphics on Ancient Egyptian walls.

Intrigued, Naudé set off on another road trip, the first of many over the next four years in which he sought to repeat his emotional encounter with these dogs. He started out in peripheral areas, such as junkyards and rural farms, asking the locals for guidance on where the dogs might be found.

Sometimes he would travel for three weeks and find only one dog, and, while some of his portraits took just fifteen minutes, others would take four hours. If he had strayed too far from civilization by the time night fell, he slept in his car or at remote police outposts.

'I wouldn't say it got easier but, after about a year, I knew exactly what I needed, pictorially. I wanted the dog to seem almost sculptural, and radiating a stillness. To do that I needed a straight horizon, the dog's eyes open, its mouth closed, a certain percentage of land and sky. It was very important to me that anyone seeing my photographs had that same intense engagement that I had had.'

For Naudé, the dogs, whose physical form varies from place to place (nearer the coast, they have longer hair; in drier parts, they are short-haired and more slender; in mountainous areas, they have bigger heads and a stronger build), came to symbolize the diversity of South Africa.

'One of the first photography books I ever bought was Richard Avedon's American West, in which the people and the clothes they are wearing somehow convey the environment in which they live and work. That's why the landscapes are so important in my photographs of dogs – they are the dogs' clothing, in a way, and I choose every one specifically. I fell in love with their barrenness, their abstract openness, the weather, the light. I was continually surprised by it.'

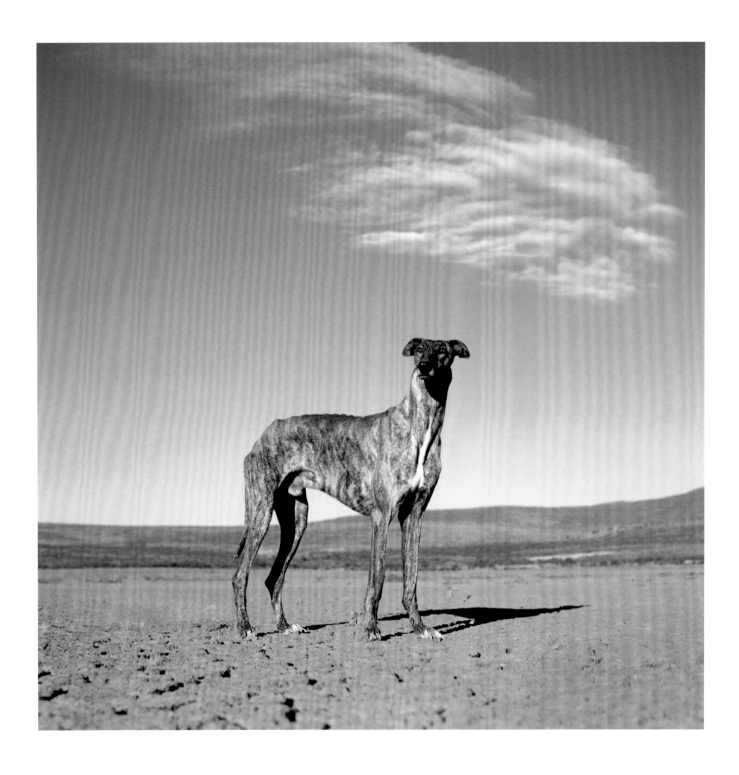

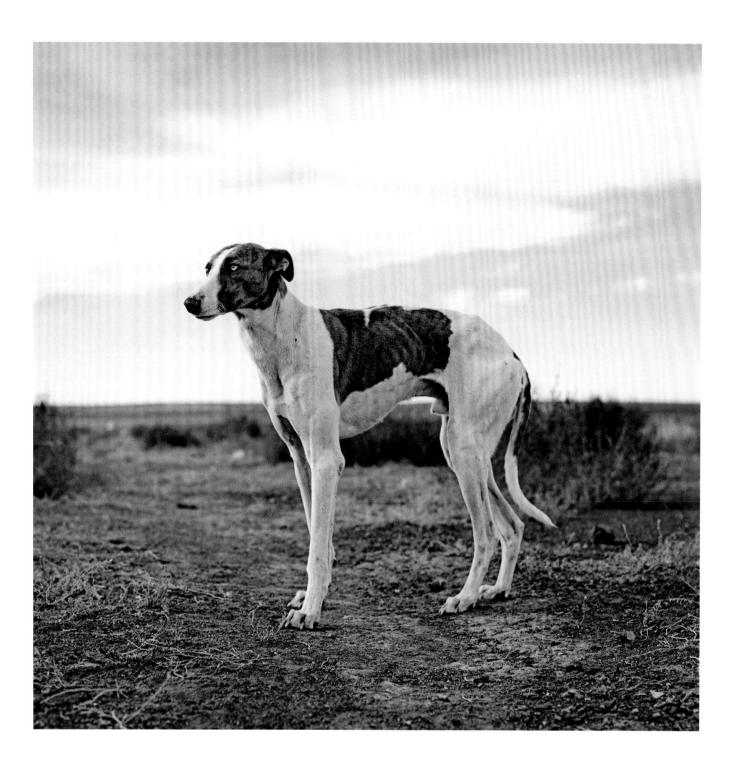

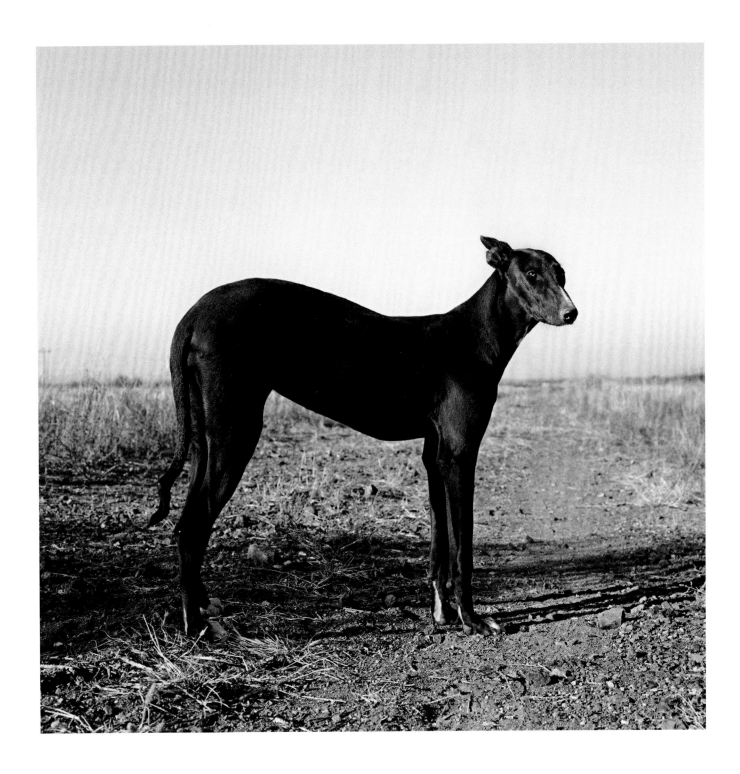

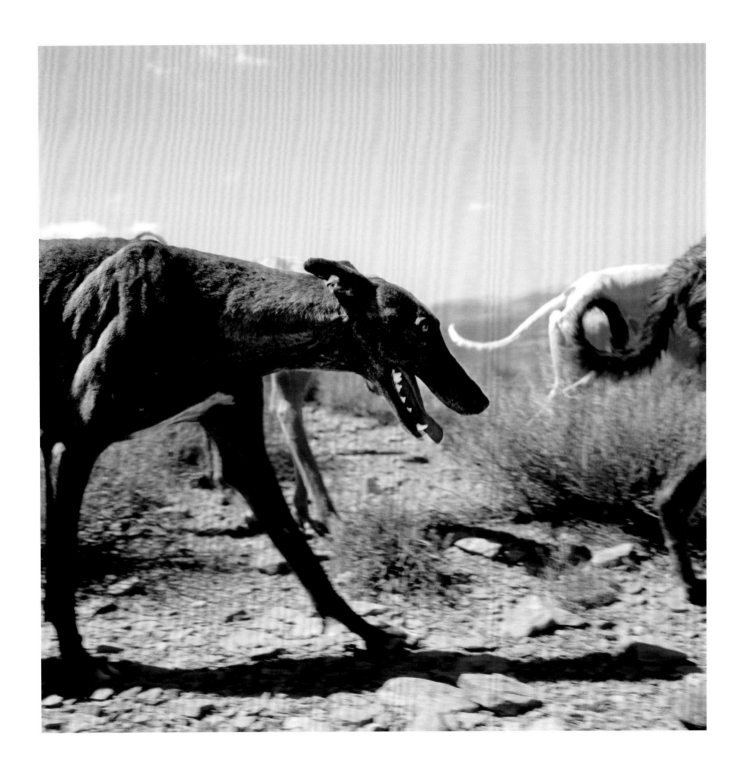

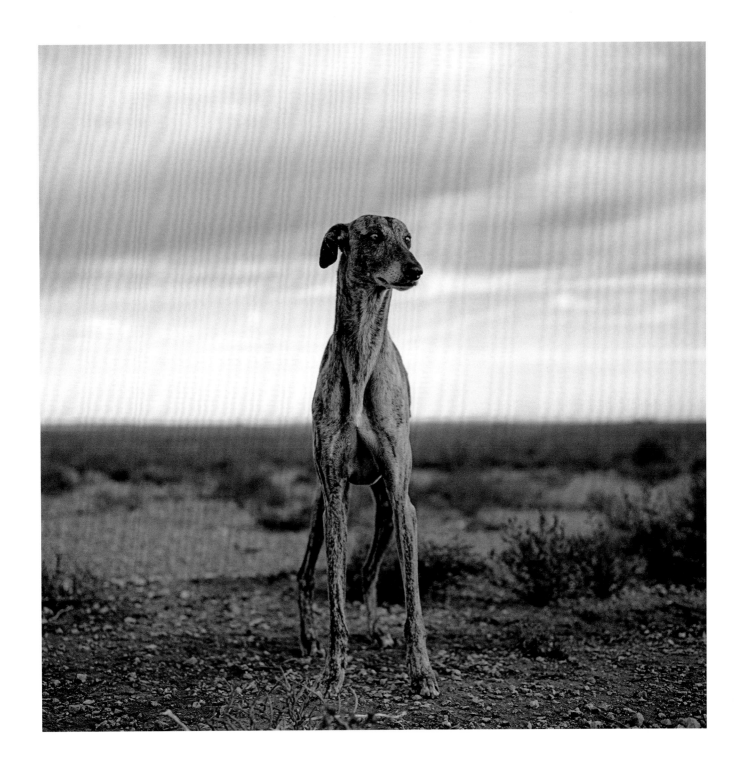

Peter Hujar

SCULPTURAL, BEAUTIFULLY TEXTURED IMAGES REVEAL
THE LATE PHOTOGRAPHER'S SOFTER SIDE

'Hujar cajoled light into the liquid pooling in the dogs' eye sockets, along glinting tufts of whiskers and between the fleshy pads of neatly placed paws'

During the seventies, when New York was at its inhospitable worst – the seedy urban jungle depicted in films such as *Taxi Driver* and *Serpico* – photographer Peter Hujar was one of the leading lights of the underground cultural scene developing Downtown, on the city's Lower East Side.

He cut a striking figure. 'Immediately you met him you were aware he was not an ordinary person,' says his friend Stephen Koch, to whom Hujar bequeathed his work when he died of AIDS in 1987. 'He was tall, with a very handsome face and he could be enormously charming. The kitchen table in his loft at Second Avenue and Twelfth Street was a place where many of us would sit for hours. At his funeral, the graveside was lined with people and all of them thought they were his best friend.'

There's no disputing Hujar's talent. When Richard Avedon died in 2004, he had more photographs by him in his personal collection than by any other photographer. Despite this, thirty years after his death, Hujar's work remains relatively unknown.

He struggled with depression and had a reputation for being difficult, which probably hampered his success. Koch once saw him throw someone down the stairs in a rage: 'I was shaken by that. You could always feel the fires of anger burning in him somewhere.'

Mostly, he photographed his art-world cohorts – actresses Candy Darling and Cookie Mueller, the drag queen Divine, author Susan Sontag lost in thought. But about thirty of the images in Hujar's archive are of dogs. Very often the dogs belonged to someone he was photographing in another capacity (he had a series of short-lived commercial jobs), or to one of his Lower East Side friends: Beauregard, for example, an exceptionally vitupera-tive gossip columnist for the *Soho News*, and the curator Clarissa Dalrymple, who owned the forward-thinking Cable Gallery.

The dog images are remarkable for their pronounced texture. Hujar, who was entirely self-taught, cajoled light into the liquid pooling in the dogs' eye sockets, along glinting tufts of whiskers and between the fleshy pads of neatly placed paws, to create photographs with real sculptural depth.

'Peter had a relationship to animals unlike anything I'd ever seen,' says Koch. Once, when they were vacationing in Nantucket for the summer, the pair went out for a drive. 'He suddenly asked me to stop the car,' recalls Koch, 'and I pulled over next to a field in which there was a bunch of cows, and he got out and began a conversation with them. It wasn't just "nice cow, how are you", it went on for an hour. He was very skilled with animals and it pleased him no end.'

There is one photograph in the archive showing Hujar photographing a dog, kneeling at the dog's level, their faces together, as if telling the dog what to do. 'You know that he's been talking to that dog for a long time,' says Koch. 'He certainly saw the dog pictures as portraits. But then he once said he wanted to make a portrait of a tree. Everything mattered to him in some way.'

BOUCHE WALKER (REGGIE'S DOG), 1981

DOG, WESTTOWN, NEW YORK (SCRUFFY DOG), 1978

Robin Schwartz

A MOTHER'S EXTENDED PORTRAIT
OF HER DAUGHTER, AMELIA, AT EASE WITH
DOGS AND OTHER ANIMALS

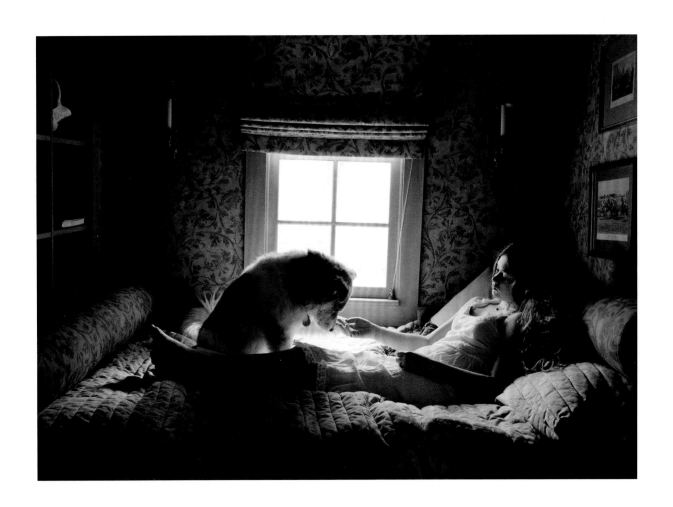

'Dogs are better than people. I'm sort of afraid of people – they're really unpredictable.'

When her daughter Amelia was a baby, Robin Schwartz would take her picture next to one of the family dogs, a white whippet named Becky, to see how much Amelia had grown. Later, the child and the whippet liked to be tucked up in bed together at night. 'They were bonded for life,' says Schwartz.

Amelia continued to conjure an exceptional rapport with every animal she encountered. And because Schwartz is an animal photographer, those encounters were frequent. It wasn't entirely uncommon for Amelia to be sitting in her cot with, for example, a chimpanzee.

Then, in 2002, two things happened that would determine the future direction of their lives. First, Schwartz, who teaches photography at William Paterson University, New Jersey, photographed the then three-year-old Amelia with a monkey named Ricky. Shortly afterwards, Schwartz's mother died, making her 'very morbid and depressed. I thought about the future, when I wouldn't be here, and I wanted Amelia to have something of our time together ... It was hard being a working mother, so I combined what I loved and had been doing for thirty years with my baby, who seemed very adept at it. You can't force that stuff.'

Her decision led to *Amelia and the Animals*, a sequential portrait of Amelia growing up, much like any parent takes of their child, perhaps, except these are with tigers and kangaroos – and dogs, of course.

It was important to Schwartz that she trusted and liked the animal. 'I don't like all animals,' she says. 'I think of them as individuals. But everything depends on that dynamic. Then, I go with the flow. If you try to plan too much, it frustrates everybody involved. This is not a set – I'm a one-person band. I might bring a rug or something, but mostly I just pray the owner doesn't have a plaid couch.'

Schwartz believes her own love of animals is innate, 'but I was also an only child and a latch-key kid. My parents gave me a cat, who I considered my brother. I had nothing to do except watch TV, so, from the age of about ten, I would use my instamatic camera to do set-ups with the cat all over the house.'

Her animal photography began in earnest in the eighties, when, for her graduate thesis, she photographed stray dogs. 'I hung out with packs in Coney Island and New Jersey. It was an extraordinary experience, but it sort of broke me. There came a point where, if I spent time with the dogs, I would start to cry. I think I identified with them: I was really on my own; almost homeless for a period of time – my father had died, my mother's relatives took her house, and she was living in a tenement where there was no room for me.'

Dogs, she says, 'are better than people. I'm sort of afraid of people – they're really unpredictable.' Last year, she was awarded a Guggenheim Fellowship to photograph 'people who have the same heart regarding animals. I look for that spark; a thing like, "you're one of my people". It's a gift.'

There are thousands of pictures in the *Amelia and the Animals* series now. Schwartz has already published two books of the images, the first in 2008 (which sold out) and the second (which won an award) in 2014.

As Amelia has grown – she is now seventeen – her input has increased; a recent offshoot of the project has seen a more ethereal, theatrical approach, using vintage gowns. 'It was nice for her to do something pretty and – more importantly – clean,' laughs Schwartz. 'Usually, when she's working with me, she just gets peed and pooped on.'

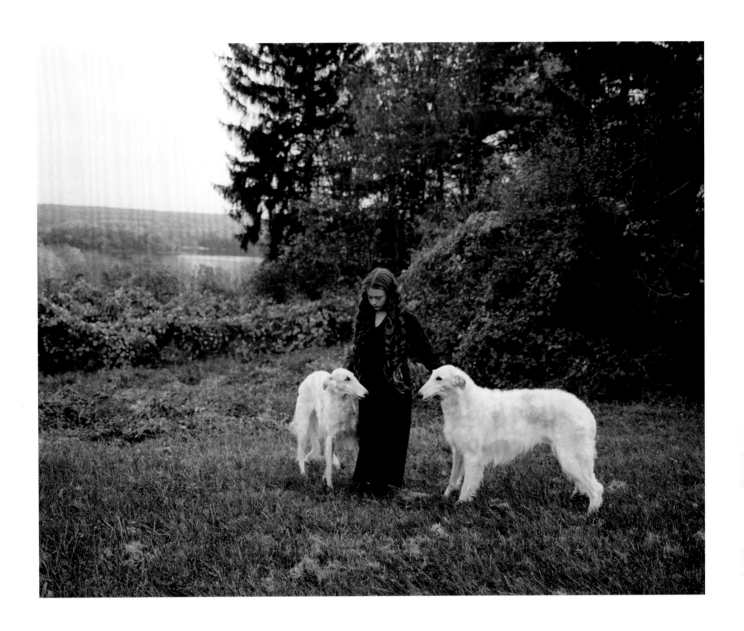

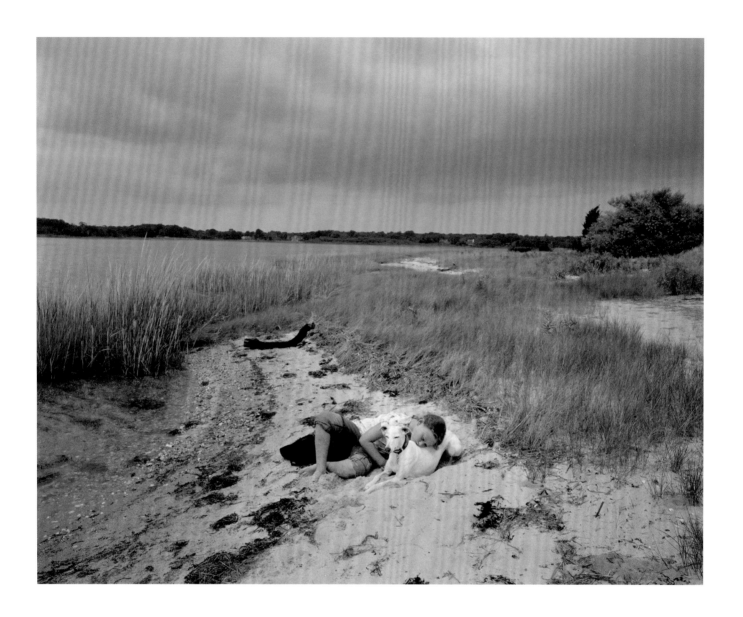

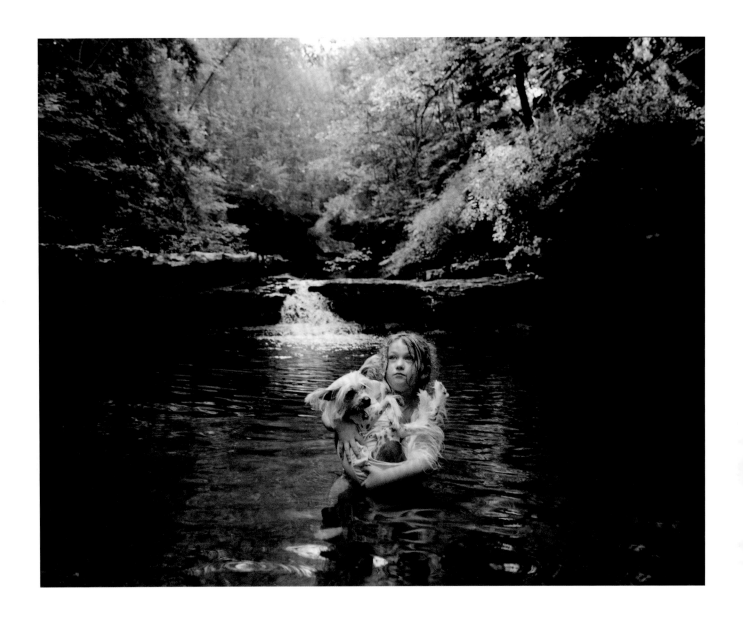

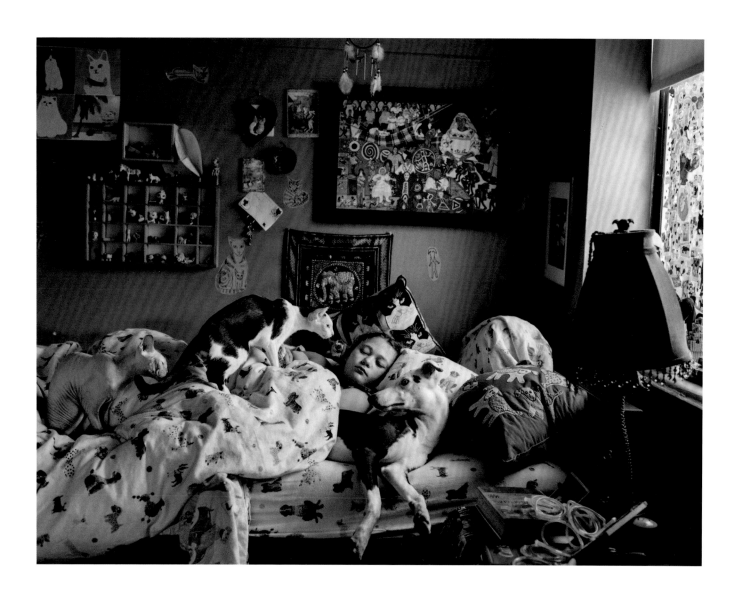

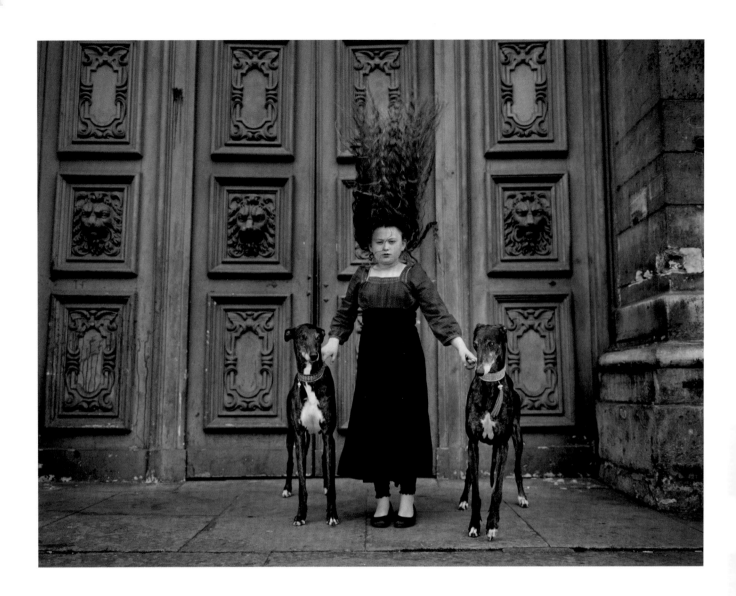

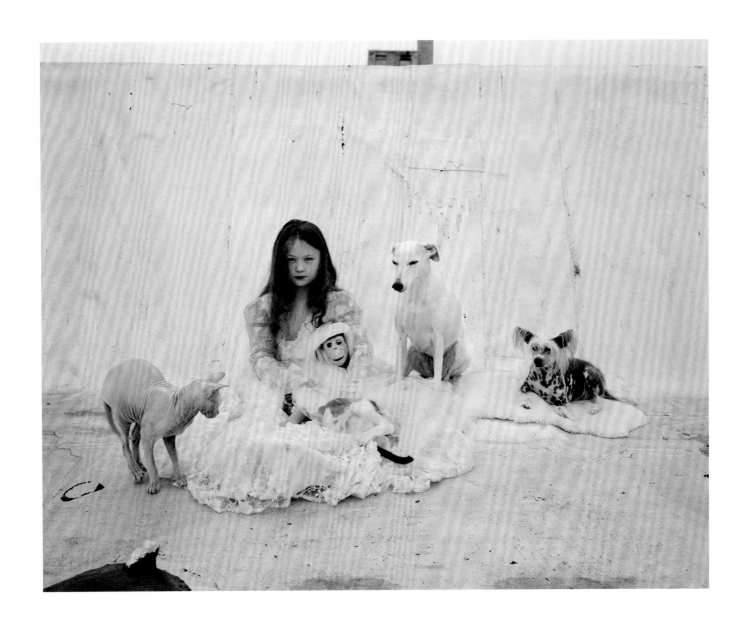

Ruth van Beek

DISCARDED PICTURES OF DOGS FROM BOOKS
AND OLD PHOTO ALBUMS TURN INTO STRANGE FLYING
CREATURES WHEN FOLDED

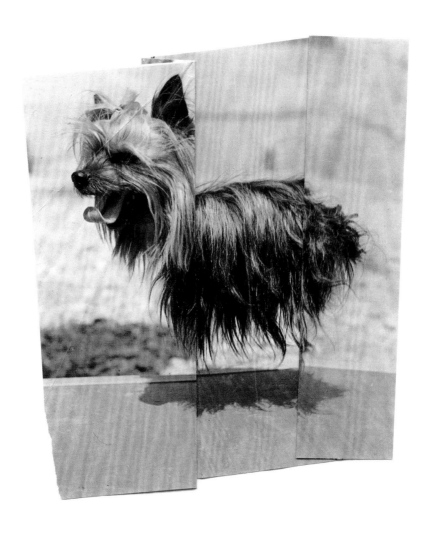

'I like my work to suggest
that when we're not looking,
dogs have their own life —
they might even be flying'

Ruth van Beek's *The Levitators* began with a happy accident. In folding and refolding a photo of a Yorkshire terrier, she realized she had removed its legs from view, and that the shadow on the ground in the original photograph made it seem as if the dog was levitating. 'It became an exercise, then an obsession, to see if I could do it again,' she says; 'to see if I could make other dogs fly'.

As a child, she had collected images of monkeys and postage stamps; faithfully pasting hundreds of each into scrapbooks with a pot of glue. But it wasn't until she was a teenager that Van Beek became fascinated by old photos.

'We didn't take many at home,' she explains. 'My parents only had one or two albums. But when I was fifteen, my mother died, and I realized I had almost no recent photos of her. My grandparents enlarged a picture in which she was in the background and put it in a frame. I was fascinated by that – it was a horrible picture, really blurred, but the value it had triggered something for me.'

She began to scour the flea markets and second-hand shops in her home town of Amsterdam, amassing other people's discarded albums. At home, she would reorganize them in unusual sequences, or turn them into little books.

One day, though, it wasn't enough. 'I felt as if the pictures still belonged to someone I didn't know. I started cutting and folding them, to try to anonymise them.' Her first successes were with dancing couples: happy moments at birthday parties and weddings, which, when folded and sliced, made the pair seem to be fighting instead of waltzing.

'I had found I could make alternative stories visible,' says Van Beek, who today makes her living from such photographic interventions. Her studio is piled high with teetering stacks of pictures, organized into categories, such as 'flower arranging', 'dolls', 'masks' and 'things with hair'.

As well as old photos, she works with images culled from discarded books, because 'everyone is throwing away their books these days'. She always cuts the book up straightaway, so liberating the images to be used in a new way.

Although she doesn't start out with a plan, she does have 'a sort of subconscious image in my head which I'm searching for, and once I recognize it, the piece is finished'. She might have to fold and refold the image several times to get to that point, 'and I like that window into my process to be visible, so you will often see my mistakes in the final piece'.

There are glorious little details to be found in her creations, if you look closely. Several of *The Levitators* include a hand holding a tail in place, or a lead pulling the dog's head up. 'It's as if the dogs don't have their own identity,' says Van Beek. 'You could say that it mirrors how we have tried to shape dogs to become domestic pets. I like my work to suggest that when we're not looking, they have their own life – they might even be flying.'

Matthew Gordon

WALKING HIS PET SPANIEL THROUGH EERIE,
HISTORY-STEEPED WOODLAND BROUGHT THIS YOUNG
PHOTOGRAPHER'S OWN FEELINGS OF UNEASE TO THE SURFACE

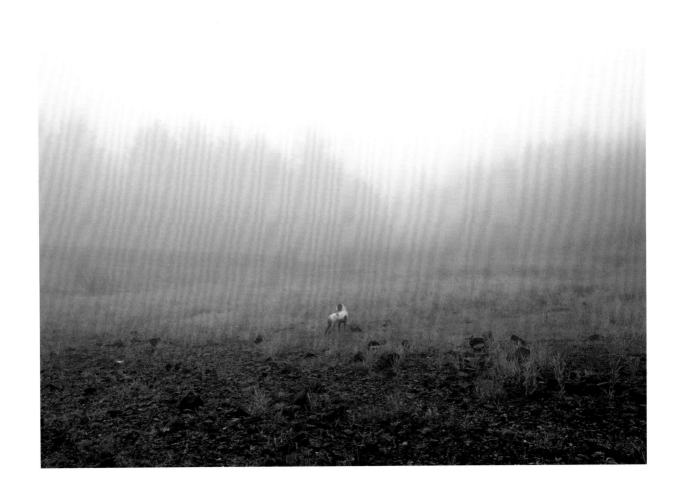

'I realized the way [my dog] was acting mirrored my own fears, and photographing him was a way of expressing what I felt.'

Woodburn Reservoir sits high in the hills above Carrickfergus, about five miles inland from the shore of Belfast Lough. Surrounded by a thick forest of larch and spruce, its four lakes, which teem with brown and rainbow trout, are popular with local anglers. 'My grandad taught me to fish there,' says Matthew Gordon, who grew up in Straid, a tiny village clinging to the forest's edge. 'It's been part of my life for as long as I can remember.'

Gordon, now twenty-three, began taking pictures in and around the reservoir while studying at Belfast School of Art. He had recently acquired a springer spaniel puppy named Joey, and would walk him at Woodburn before lectures started in the morning.

Joey is his second spaniel – the first was knocked down by a car when he was eight years old. 'My dad took it quite badly, so we didn't get another, then. I found Joey through an ad in the paper and I just came home with him. My mum wasn't amused – she's come around since – but my dad was secretly very pleased.'

Woodburn, he says, 'is a strange place. Especially in the winter, because it's high ground, it can be foggy and murky and very eerie. Sometimes the fog is so thick you'll be able to hear someone talking a couple of metres ahead of you, but you can't see them until you're almost on top of them.'

Around the time he began walking Joey at Woodburn, a man went missing in the area. 'I kept seeing posters and thinking, What if I found a body? My parents said that during the Troubles, bodies were discovered in the water all the time. Eventually, they found the missing man in one of the lakes – he had killed himself. I think that unease I felt found its way into my photographs.'

Of the twenty-three images in the series, about two thirds feature Joey. 'I realized the way he was acting mirrored my own fears, and photographing him was a way of expressing what I felt, without being obvious about it.' Most were taken on the marshy ground inside one of the reservoirs which had been drained for maintenance. 'Joey would hear the banging of the workmen – we couldn't see them in the fog – and it startled him. He would stop dead and look around him, and back at me, as if asking whether things were okay.'

The series was inspired by the work of Willie Doherty, a fellow Northern Irish artist (twice nominated for the Turner Prize), whose photographs suggest that history can mark a landscape. 'I liked the way Doherty uses landscape to tell a story without being too literal about it,' explains Gordon. 'I tried to use the atmosphere of the place in the same way. That landscape is as old as time, and I'm only in my twenties. My experience of it is just a minuscule moment in its lifetime.'

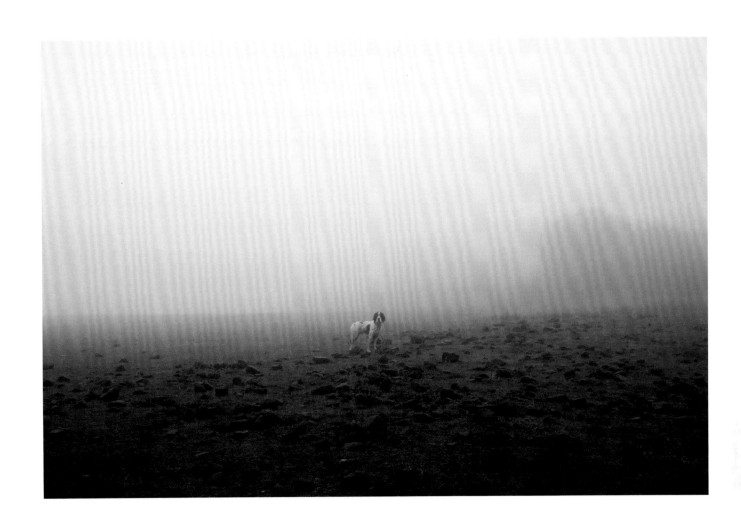

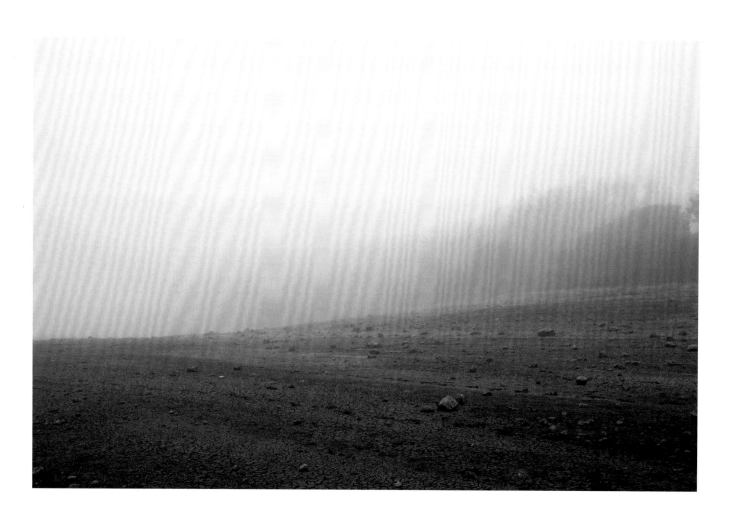

WOODBURN, CARRICKFERGUS, CO. ANTRIM, NORTHERN IRELAND, WINTER 2013

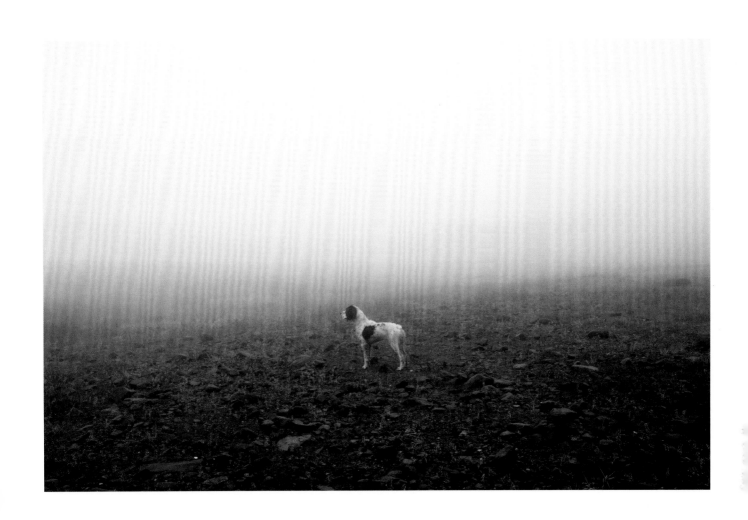

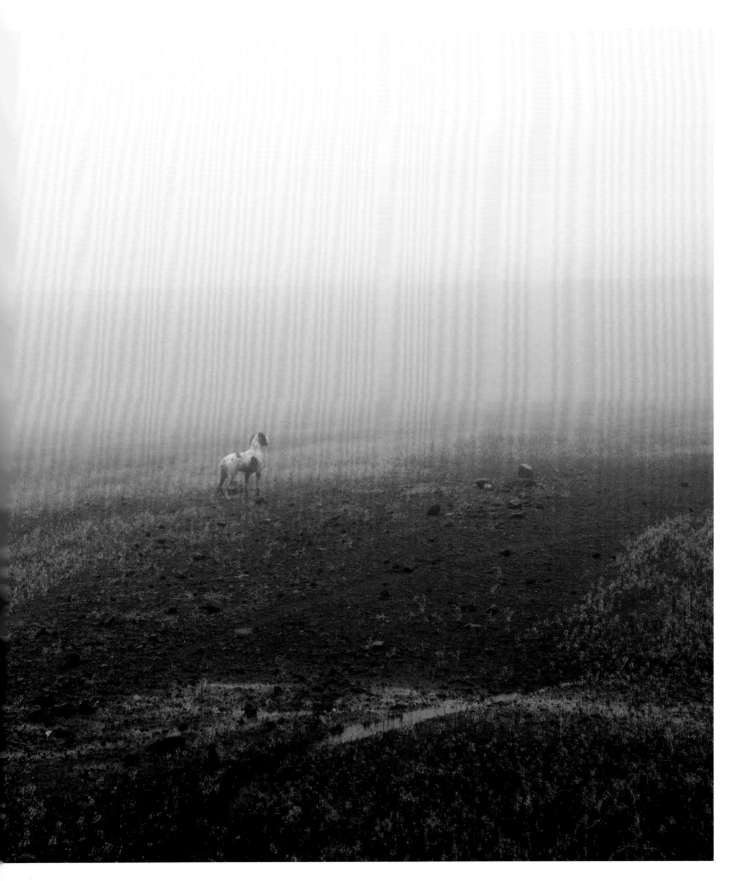

Tim Flach

THOUGHT-PROVOKING PORTRAITS
SUGGEST THE FINE LINE WE TREAD IN SHAPING
DOGS TO SUIT OUR NEEDS

It was horses that put Tim Flach on to photographing dogs. While taking pictures of specialist equine breeds such as the Haflinger and the Arabian, both of which have been bred for a certain look, he became intrigued by the way in which we have shaped certain animals to suit our needs.

'We've determined the outcome of the canine species more than any other,' says Flach, whose work sits as comfortably in *National Geographic* as on museum walls and on billboards, too (he has shot campaigns for English National Opera and Hermès). 'Perhaps it's because the dog has a unique place in our own development. It's become a kind of companion animal – less kennel, more sofa. Sometimes that has been at the cost of its health and comfort.'

Dogs Gods, so-titled because 'we treat dogs like gods in the home,' includes both trained and domestic dogs, as well as pedigrees and mongrels. Flach travelled all over the world to collect his thirty subjects – Dallas and Iceland for example, even Tibet.

He knew he wanted Dalmatians – the breed has a genetic predisposition to deafness, especially in dogs with white rather than black ears, and with spotted rather than patched coats. To obtain the idea of the comfort dogs have been shaped to provide, he photographed the Dalmatians looking like a blanket. 'It was a litter of thirteen puppies in their owner's back kitchen – they have a very short wake/sleep cycle, so after a few minutes' play, they collapsed in a heap.'

Flach captured some of the dogs at work – the Beaufort Hunt hounds, for example – but most were photographed in a studio. 'I like to be able to bring some stylisation to my pictures,' Flach explains, 'to give them a context more associated with human representation. That requires being at their height and establishing a level of intimacy, to give them the dignity and poise you'd expect in a formal picture of a person.'

Though he begins with a framework for the shoot in mind, he prefers events to unfold by themselves once it starts. 'It's like Picasso said, "I do not seek, I find". Often when you're photographing an animal, they do something better than anything you had imagined.'

He isn't averse to using a piece of cheese or a toy as persuasive tools, 'but in evolutionary terms, dogs have been bred to collaborate with and please us, so it's not usually difficult to get them to do something. It's actually harder to make them growl at you.'

Over the years Flach, who has also photographed bats, owls, primates and many other species, has found himself more attuned towards animals than humans. 'I'm someone who likes to observe,' he says, 'and while, yes, there is a randomness to animal behaviour, if you look carefully, there is also a pattern. It's surprising how much I can predict and so manage the shoot accordingly.'

That said, he sometimes runs into trouble. A particularly ferocious mastiff in Tibet, for example, or the four-year-old Hungarian Puli named Andy who kept running under rather than over the jump which Flach had hired to catch his mop-like coat in full flight. 'I'd had high speed flash brought in on a plane from Los Angeles, hired a studio in Dallas. It had me worried, having invested so much in that one picture, but in the end little Andy performed extremely well.'

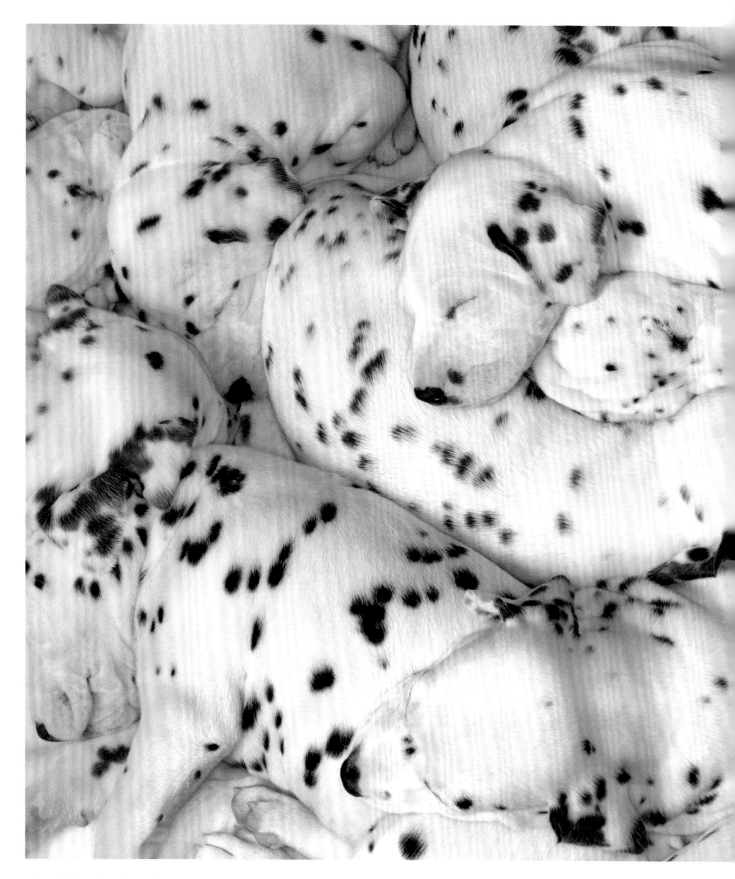

DOGS GODS, DALMATIAN, 2010

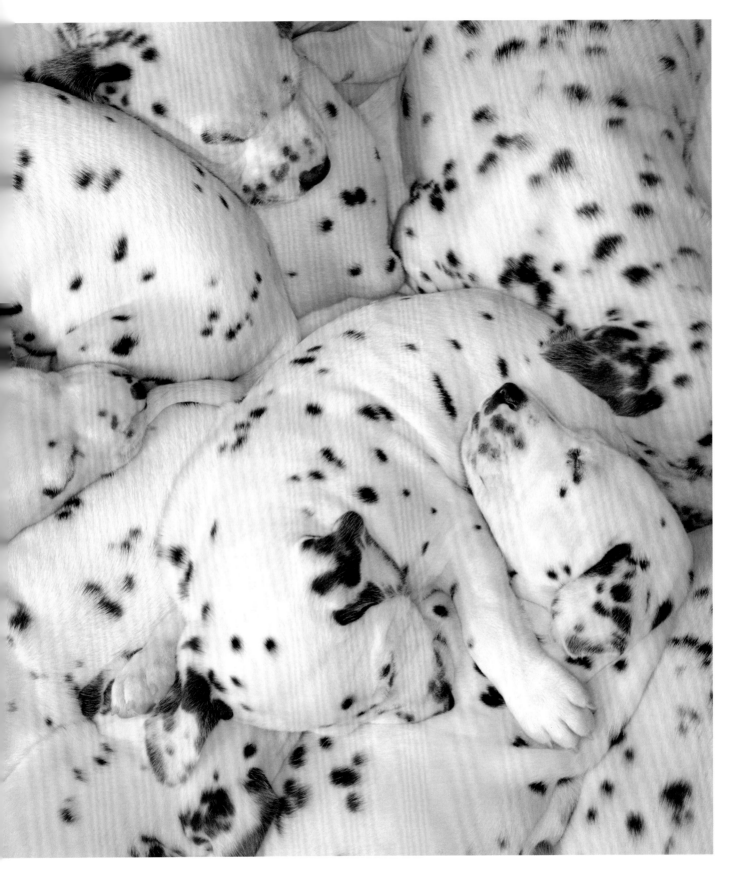

Andy_0001 Andy_0002 Andy_0003 Andy_0004
Andy_0009 Andy_0010 Andy_0011 Andy_00012
Andy_0017 Andy_0018 Andy_0019 Andy_0020
Andy_0025 Andy_0026 Andy_0027 Andy_0028

DOGS GODS, CONTACT SHEET OF PULI, 2010

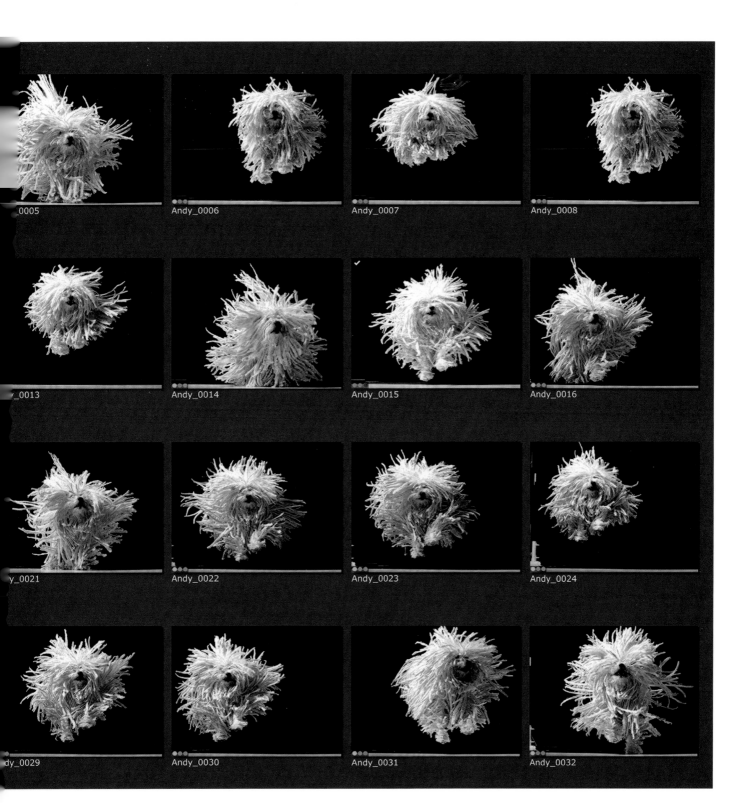

_0005 Andy_0006 Andy_0007 Andy_0008

_0013 Andy_0014 Andy_0015 Andy_0016

y_0021 Andy_0022 Andy_0023 Andy_0024

dy_0029 Andy_0030 Andy_0031 Andy_0032

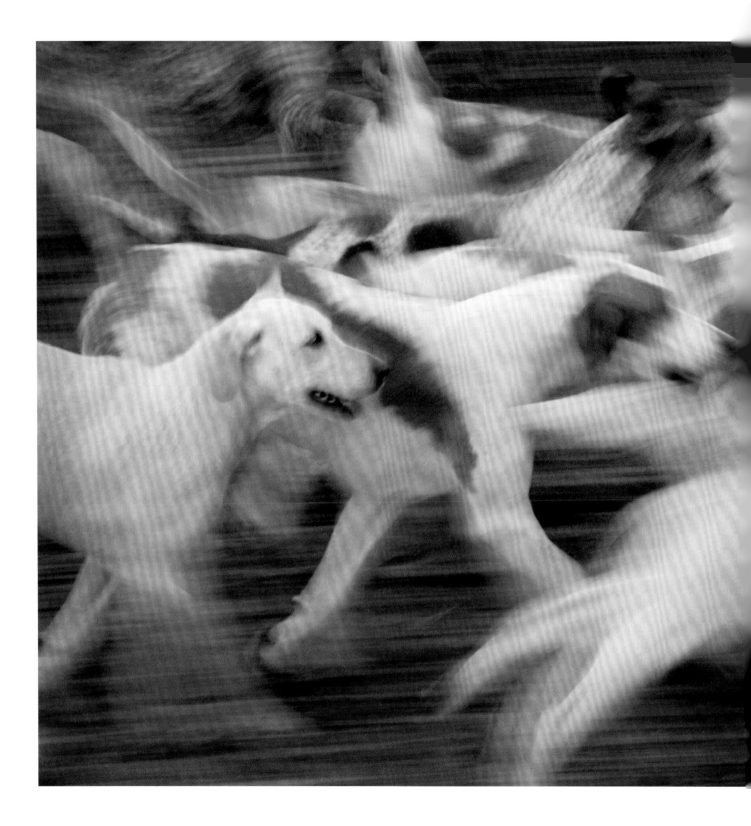

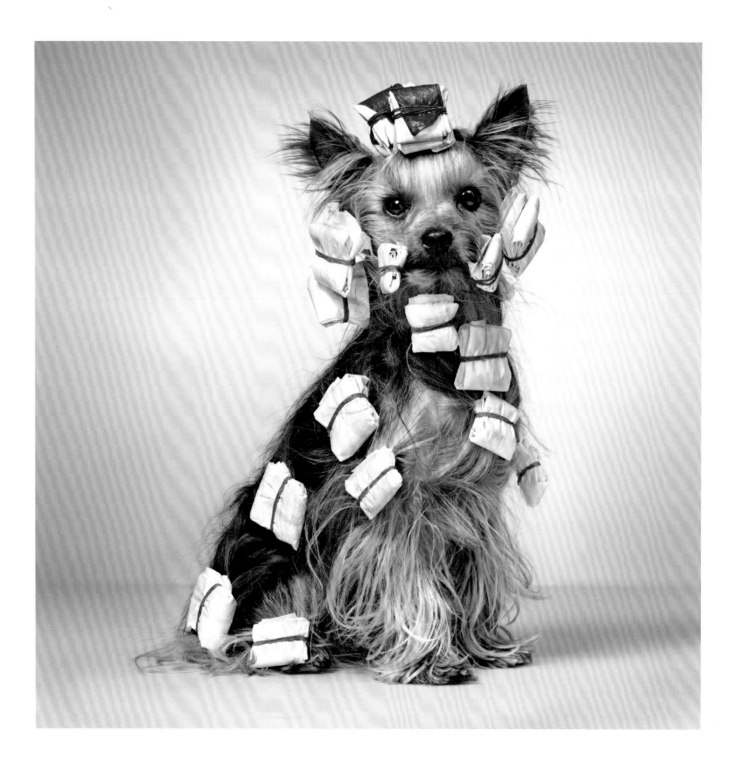

DOGS GODS, YORKSHIRE TERRIER IN CRACKERS, 2010

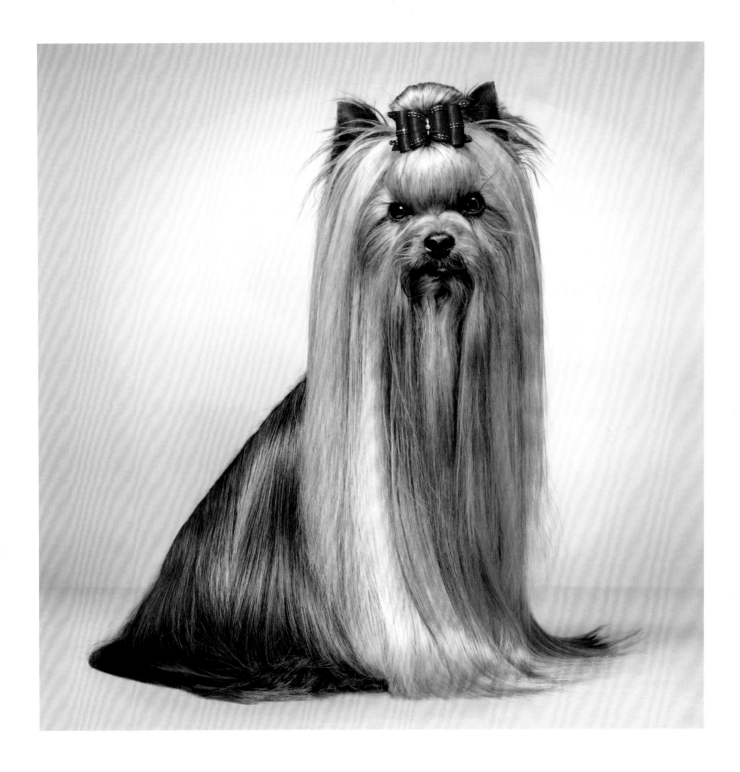

Elliott Erwitt

QUIRKY, WITTY IMPRESSIONS OF THE DOG WORLD
FROM THE VETERAN MAGNUM PHOTOGRAPHER

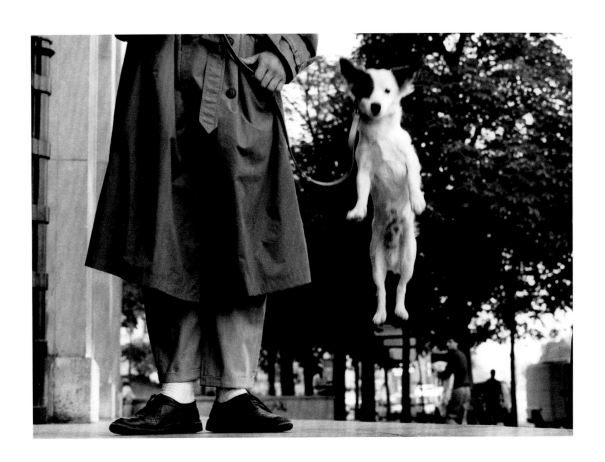

'My life has been quite interesting professionally,' says Elliott Erwitt, with one of the understatements he is renowned for. This is the photographer who first chaperoned 'good' documentary images of dogs to a wider audience, but, during sixty-odd years in the business, that isn't all he's been up to.

For the photo agency Magnum, he has covered news assignments all over the world. He was also commissioned to photograph Beat author Jack Kerouac just after *On the Road* was published (1957), and Hollywood royalty such as Marilyn Monroe, on the set of *The Misfits* (1961), and Marlon Brando for *On the Waterfront* (1954).

But the pictures that made him famous were of a political bent: the first photos of the Sputnik launch in 1957 (he gained access by pretending to be part of a Soviet TV crew), and the 'Kitchen Debate' picture of Richard Nixon and Nikita Khrushchev engaged in vigorous, lapel-jabbing argument in 1959.

The latter was one of his stolen 'snaps', taken while he was meant to be photographing fridges at an industrial fair in Gorky Park. It is this lifelong habit of dividing his energies (one employer christened him 'Snapz Pikaso' for his habit of carrying two cameras, one for his main assignment, the other for things that took his fancy) that has led to his notable knack with dogs – that, and the sheer love of them. Several colleagues have reported him barking at them, as if having a conversation.

Erwitt began photographing as a teen, having fled Paris with his Russian émigré parents on the last safe-passage ship to the United States in 1939. His break came in 1951, when he was back on French soil and assigned as photographer to an American Army unit. While fulfilling his commission, he also took pictures of recruits killing time in the barracks. *Bed and Boredom*, as the series of images was called, won second prize and $2,500 in a contest run by *Life* magazine.

He has said before that his fascination with dogs crept up on him gradually. One day, he just realized that his archive contained a litter of them, in all shapes and sizes. Indeed, P. G. Wodehouse, who wrote the introduction to Erwitt's first dog book, *Son of Bitch* (1974; Erwitt has since published three others on the subject), said that the photographs possessed 'no beastly class distinctions … Thoroughbred or mutts, they are all here.'

People are usually incidental, and often conveyed via their legs or shoes, which is, of course, how a dog must see us, most of the time. And many of the images seem to share a relish of life's simple pleasures – burrowing into sand at the beach, leaping on to their football-kit-wearing child owners, wet and dirty, and panting joyously after a run with a hunting party in the Scottish heather.

With that rare combination of wit and warmth, Erwitt's success in photographing dogs comes down to one simple fact: his belief that dogs are in essence no different to humans. 'They're people with more hair, essentially,' he has said. With one exception: 'They don't ask for prints.'

USA, NEW YORK CITY, 1973

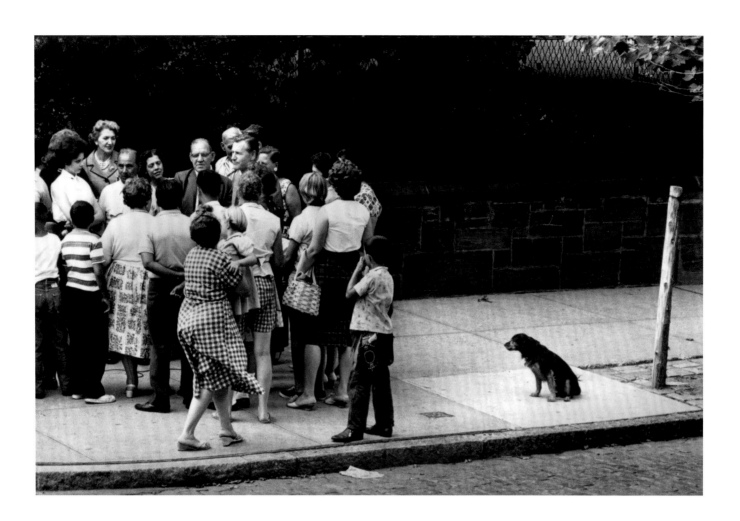

USA, NEW YORK, ALBANY, 1962

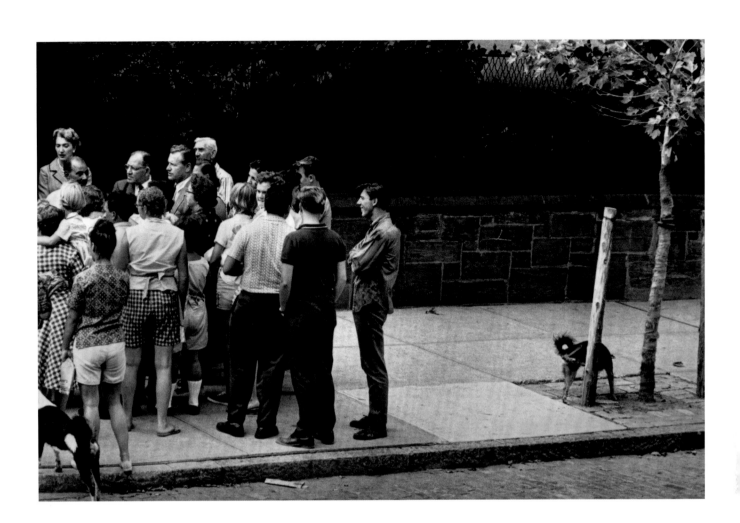

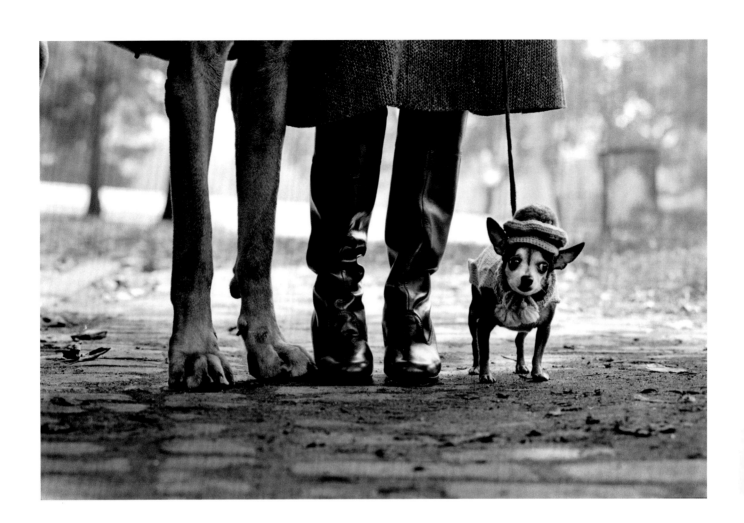

Martin Usborne

THE BEAUTY AND SUFFERING OF SPANISH HUNTING DOGS

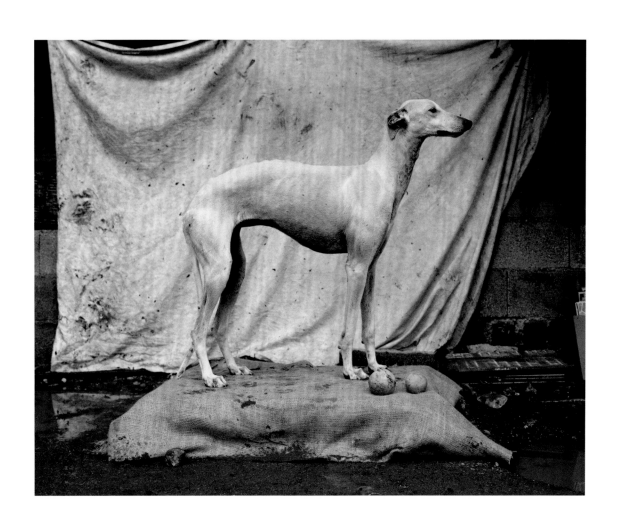

'There are so many contradictions in our behaviour towards animals. I want my photographs to examine that.'

During Spain's Golden Age, the great flowering of cultural and courtly brilliance which characterized the late sixteenth and seventeenth centuries, the galgo – a type of greyhound – had real cachet.

Prized in treatises on the art of hunting for its deft agility, the dogs boasted an ancient and distinguished lineage. They were considered valuable enough to warrant mention in a nobleman's will, and any miscreant caught harming one could be detained at His Majesty's pleasure.

But since then these lithe, long-boned creatures have suffered a cruel fall from grace. Though still the dog of choice for those who hunt hares throughout rural Spain, today the galgo is too often seen more as a tool than as a sentient creature.

Once the winter hunting season is over, or the galgo beyond its athletic prime, the dogs are often dumped by the roadside and left to die. Very occasionally, and particularly if the dog has performed badly, they are thrown into wells, set fire to or hung from trees. Local experts believe that some hundred thousand are abandoned or killed in this way each year.

For Martin Usborne, a fine-art photographer with a serious affection for dogs (past series include the haunting *Dogs in Cars*; and *My Name is Moose*, which pictures day-to-day life through a miniature schnauzer's eyes), this was deeply shocking.

In the middle of a project in which he was trying to save as many animals as he could in one year, Usborne travelled to Spain to work in the rescue shelters which take in and rehabilitate abandoned galgos and other hunting dogs, such as the smaller, stockier podenco.

Stationed in the rural area between Seville and Malaga, he was taken aback by the beauty of the landscape, which felt at odds with the terrible things happening there. One day, while photographing its plunging ravines and wild plains, he came across the corpse of a dog. 'I saw suddenly that the dogs and the landscape were completely interconnected,' he says. 'Not only did the galgos hunt within it, but so often they died by the sides of its roads and in its rivers.'

Looking for a way to represent the galgo's majestic ancestry, Usborne turned to the paintings of Diego Velásquez (1599–1660), the Sevillian artist whose subtle harmonies of colour and naturalistic approach made him the toast of Europe at the very same time the galgo's status was at its zenith.

The portraits of the dogs, which make expert use of Velásquez's chaste palette, are presented as diptychs, alongside landscapes in which galgos have been found or killed. Though they radiate a refined, Old Master-ish feel, the ugliness of the dogs' modern situation is always visible, even if only in an awkward, hunched stance, a skittish eye, or a prominent ribcage.

In the interests of seeing both sides of the story, Usborne also spent time with a group of hunters, 'all of whom seemed perfectly nice,' he says. 'It's a strange situation, because they really care about their dogs, but then they kill them – how does that work? There are so many contradictions in our behaviour towards animals. I want my photographs to examine that.'

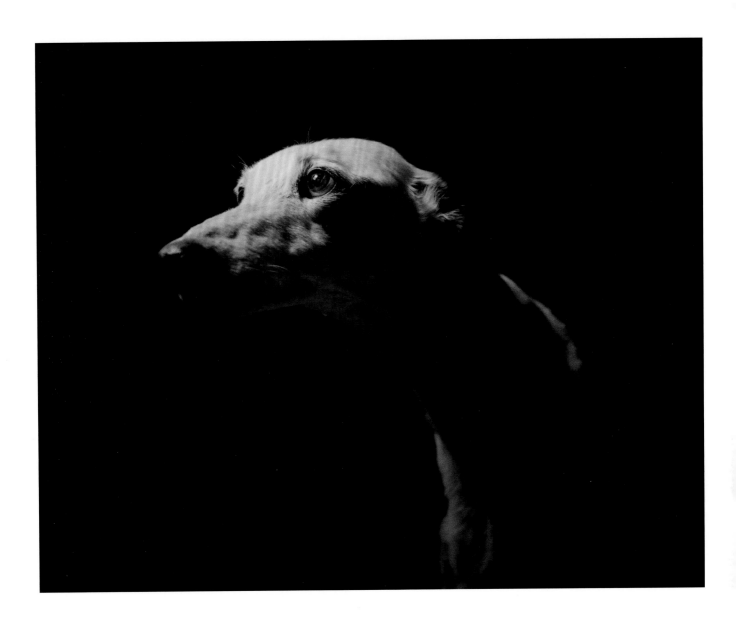

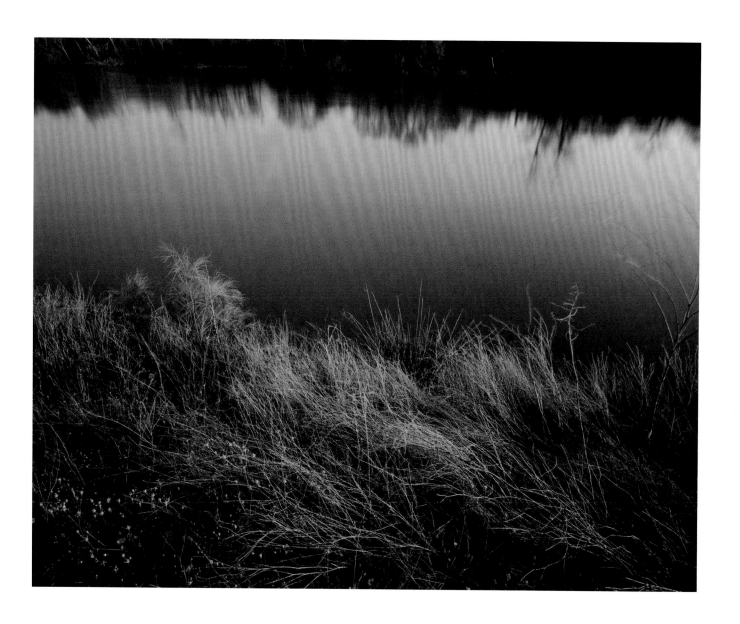

WHERE HUNTING DOGS REST, RIVER AND GALGO (DIPTYCH), ANDALUSIA, SPAIN, 2014

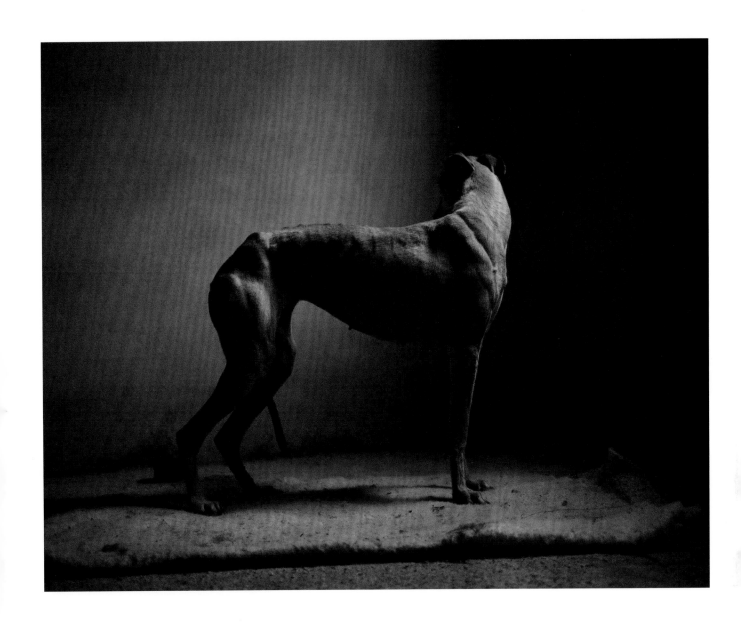

WHERE HUNTING DOGS REST, OLIVE TREE AND GALGA (DIPTYCH), ANDALUSIA, SPAIN, 2014

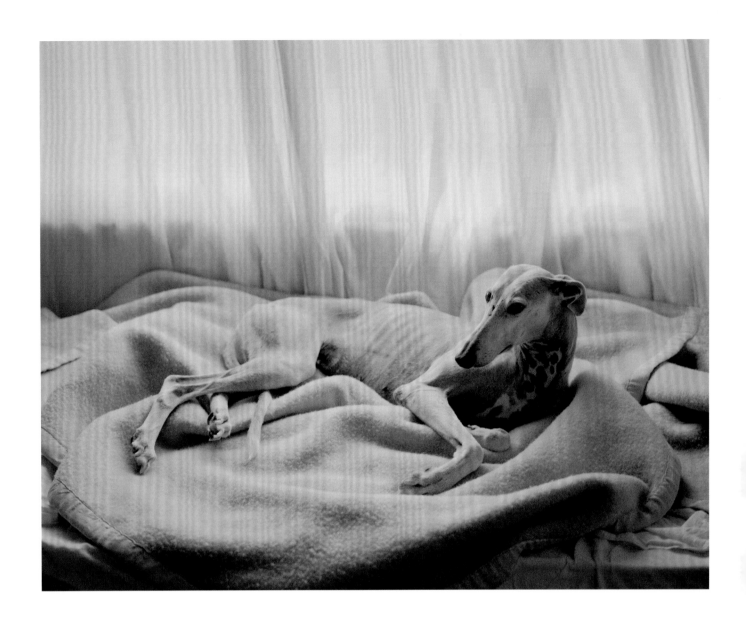

John Divola

RAW, EXHILARATING IMAGES OF DOGS
CHASING THE PHOTOGRAPHER'S CAR THROUGH
THE CALIFORNIA DESERT

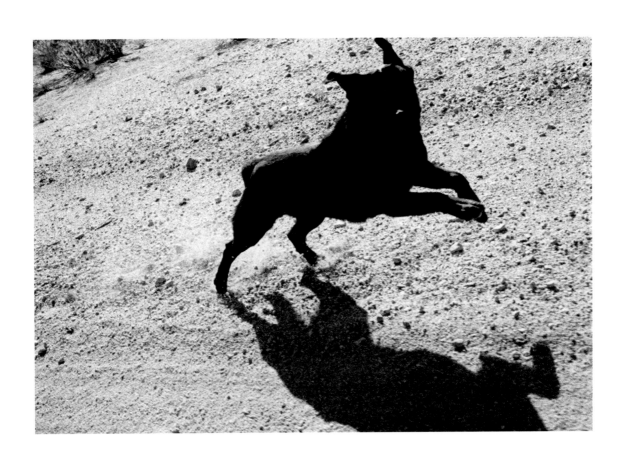

'No one sneaks up on a dog in the desert,' says the American photographer John Divola, who took these pictures with one hand suspending his camera out of the car window, the other controlling the steering wheel.

The series, which occupied Divola on and off for five years, began in the mid-nineties, when he was photographing isolated houses in southern California's Mojave Desert, between Las Vegas and Palm Springs.

In a landscape such as this, he explains, the quiet is so acute that 'a dog can hear your car coming for several miles, and will see you coming from almost as far away. By the time you arrive, he has developed a level of anticipation.'

Driving the sun-baked, grit-studded tracks, he took to photographing his uninvited but ever-present canine convoy. Having pre-focused the camera and set his exposure, he would take anything from a few shots to an entire roll of film, depending on the dog's enthusiasm.

Most of the photos capture one-off encounters, although, if he came across a particularly effervescent dog, Divola would drive back for more. The dogs never got used to the car: 'Dogs that like to chase cars like to chase cars,' he says. 'I assume they don't have anything else to do all day, and that it's delightful to see a car come by. They probably chase their owner's car.'

Though Divola is quick to point out the humour implicit in the photographs (the dogs' effort to catch the car is as idiotic as it is heroic, he notes), his images engineer a raw and unusual beauty from their subject. They are agitated, edgy things, which pulse with exhilaration and unpredictability. Many of his photos possess the grain and energy of a charcoal sketch.

Several capture the dogs in full flight, muscles taut and all four legs off the ground. These are direct descendants of the ground-breaking animal-locomotion studies made by photographer Eadweard Muybridge in the 1870s, which proved (for a wager made by his horseracing-mad sponsor, no less) that when a horse runs all four of its hooves are airborne at once.

Divola dismisses any suggestion of aggression in these images. 'I don't in any way assume their instinct to chase the car was dangerous,' he explains, 'but then I've always felt very comfortable with dogs.' Owner to puppy Luna, the latest in a long line of golden retrievers, he actually lived in a dog kennel as a college student, in exchange for free accommodation. 'I find dogs to be great companions,' he adds. 'Retrievers are particularly positive entities; happy to see anybody, not just you. It's nice to be around that energy.'

Perhaps that's why, even though the connection between Divola and the desert dogs in these photographs is fleeting and he is always at least one remove from his subject (he does not know these dogs, is only passing through and is, after all, inside his car), the images he has conjured have a warm-hearted buoyancy that is entirely beguiling.

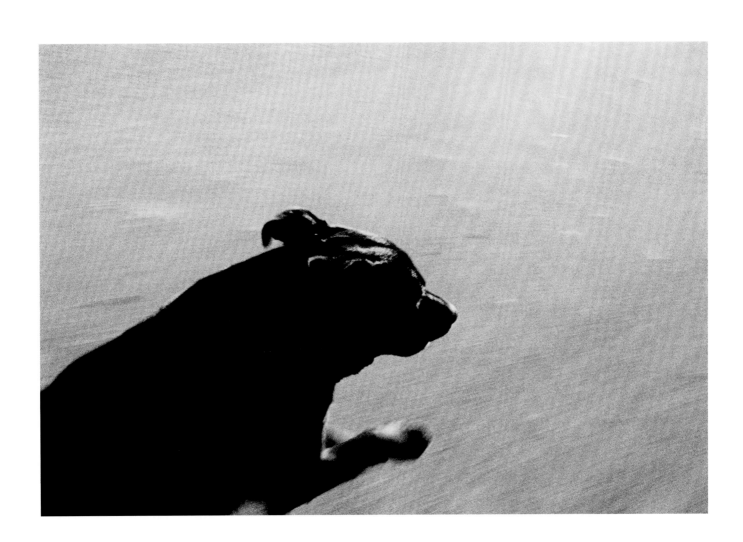

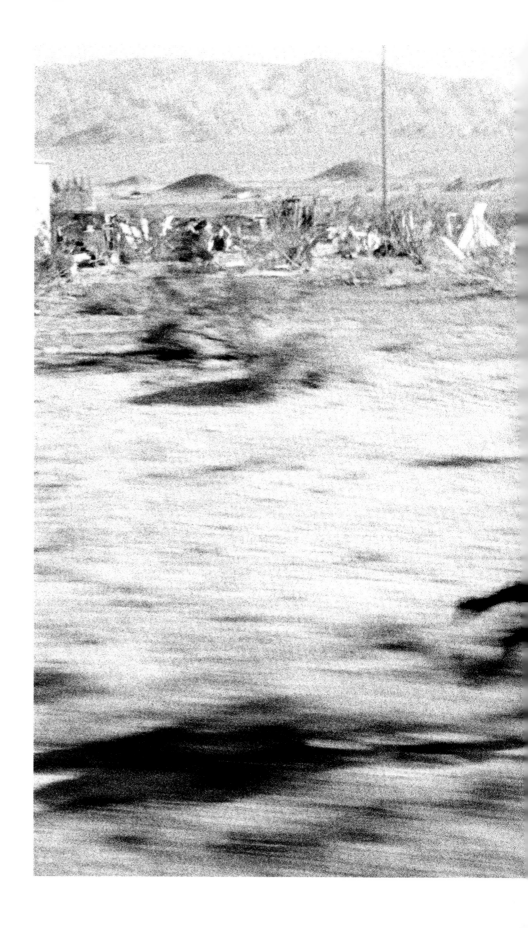

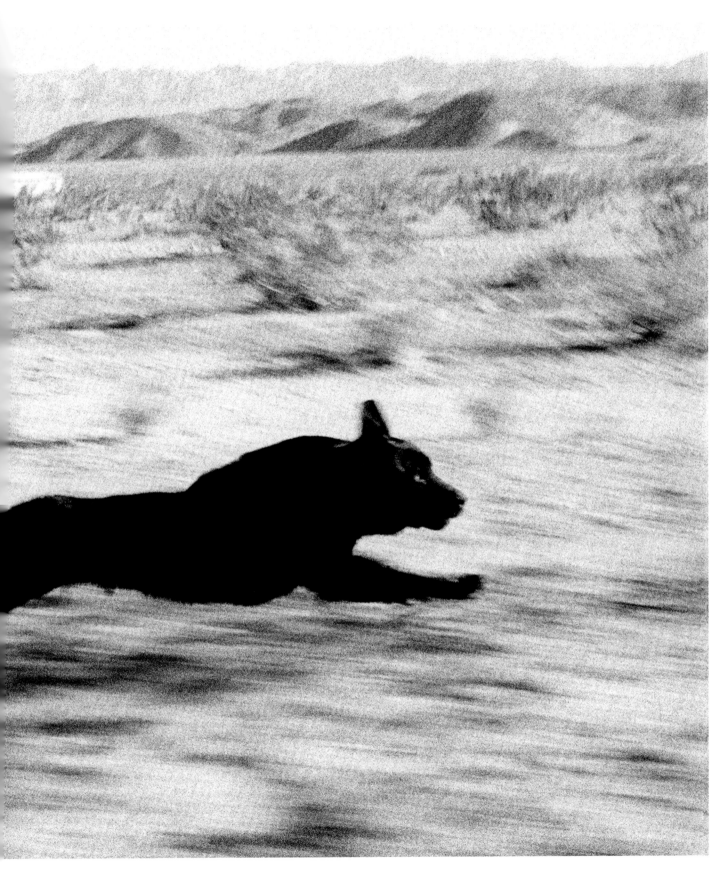

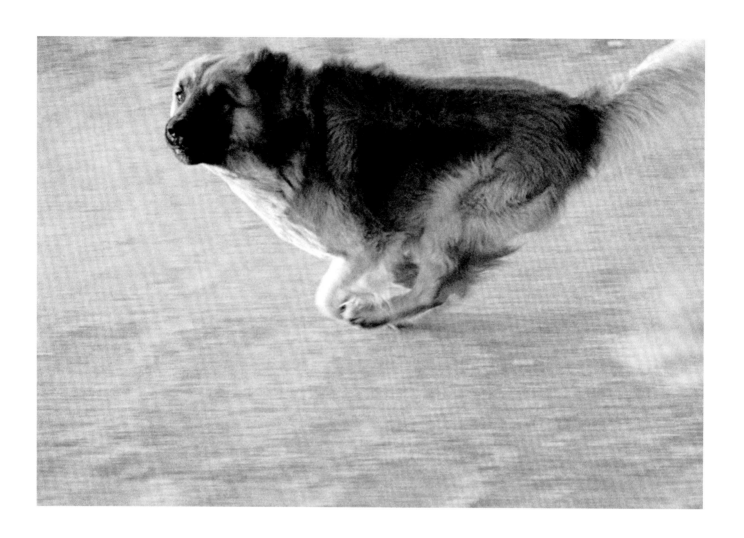

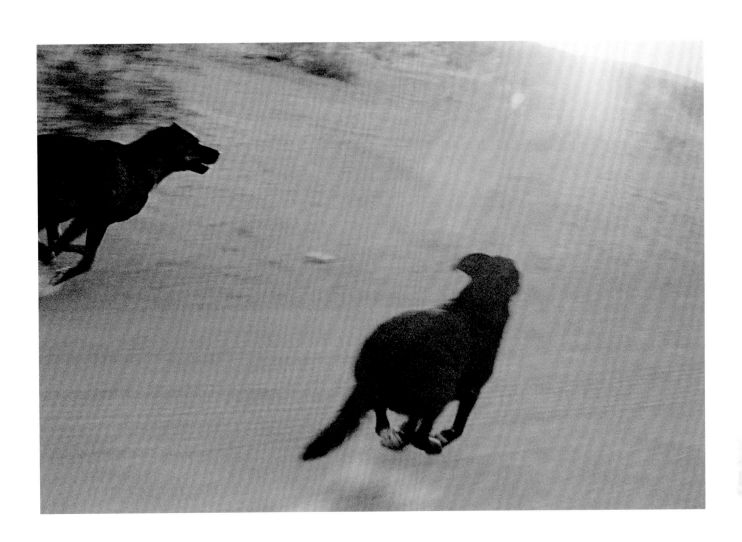

Mark Ruwedel

WEATHER-BITTEN, TUMBLEDOWN DOG
HOUSES IN THE CALIFORNIA DESERT
SUGGEST FADED HOPES AND HUMAN FOLLY

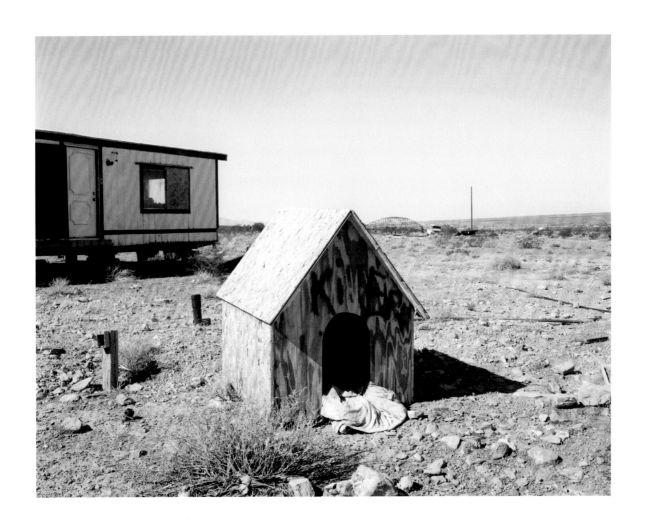

'If my dogs jumped out of
the car and made a beeline
for the structure, I knew,
no matter what it looked like,
it was the dog house.'

In the early eighties, when he was in his thirties, artist Mark Ruwedel began driving solo across the deserts of Canada and the United States. Gradually, it became clear that its bare-boned terrain was just the thing for his creative interests. 'The structures of things are very obvious in the desert,' he says. 'They just sit there, waiting to be seen. I became addicted to the process of going out there, looking.'

Often as not, his focus is debris left disintegrating in the sand and scrubland; blunt evidence of the outlaws and pioneers who have at one time tried to tame the desert or traverse it. He spent fifteen years making the series for which he is probably best known. *Westward the Course of Empire* was a ravishing study of remnants of the rail tracks on which frontier-bound trains sashayed their glorious way towards the American West.

More recently, he has been occupied with *Desert Houses*, which pictures isolated homesteads in varying states of decline; rotting hulks of buildings which can't help but carry the imprint of the men and women who lived and worked and, sometimes, died out there.

Men, women and their pets, that is, because while he was out prospecting for the abandoned homes, Ruwedel spied a dog house out of the corner of his eye, 'which was nothing special in itself, but looked amazing in the light', and took a photo – in colour, unusually for him. Thus came *Dog Houses*, a satellite project now fifty-three pictures strong, cataloguing outdoor canine sleeping quarters.

Ruwedel quickly discovered that there was a kind of ur-dog house, with a pitched roof and arched door, 'which, for all I know, comes from the Saturday cartoons. But there were really wacky alternatives, too.' Like the human houses which they squat outside, many have been cobbled together from salvage, every wall a different material. One was made from the plastic liner of a pickup truck turned upside down. 'Another was so abused there was nothing left of it but the front and the base, like the false-front houses used on movie sets.'

Some were so questionable that Ruwedel was unsure whether they were dog houses at all. In those cases, he sought confirmation from the experts, his Jack Russells Betsy and Eddie, the latter named after the artist Ed Ruscha. 'If they jumped out of the car and made a beeline for the structure, I knew, no matter what it looked like, it was the dog house.'

A big part of the reason Ruwedel is drawn to these decrepit structures, whether relics of the railroad or crumbling homes, is the failure of manifest destiny which they represent. 'This idea of going west, "lighting out for the territory", as [*Huckleberry Finn* author] Mark Twain said. When you do that now, you end up in LA. If you want the frontier, you have to turn around and head back east a couple of hours, into the desert. The houses represent it on an anonymous level; it's what the railroads represented on a colossal economic and political level. The dog houses are a kind of humorous echo of that.'

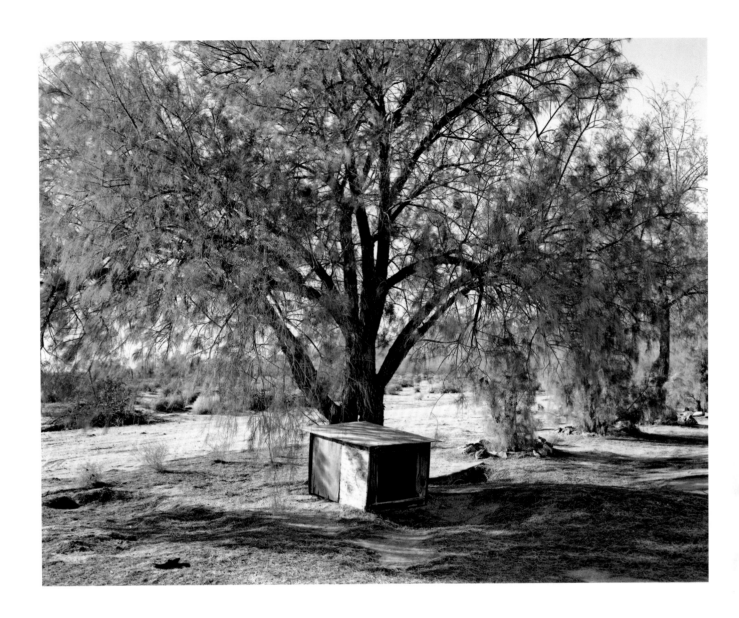

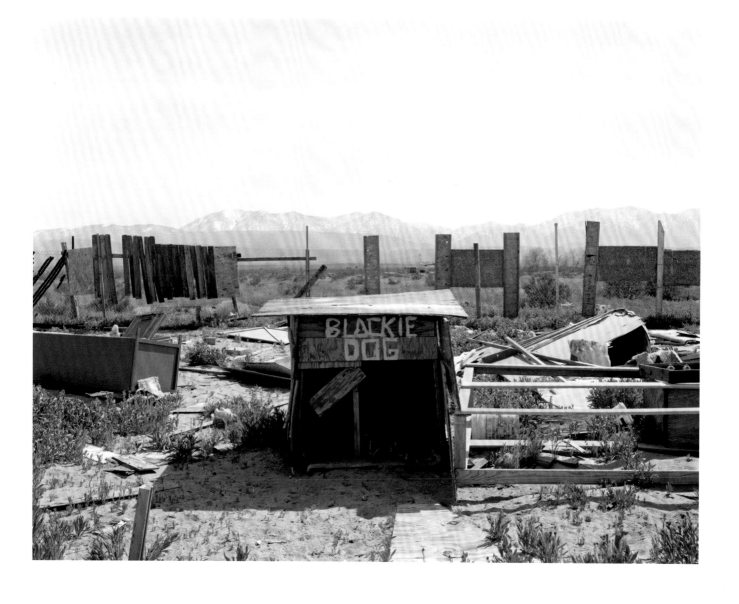

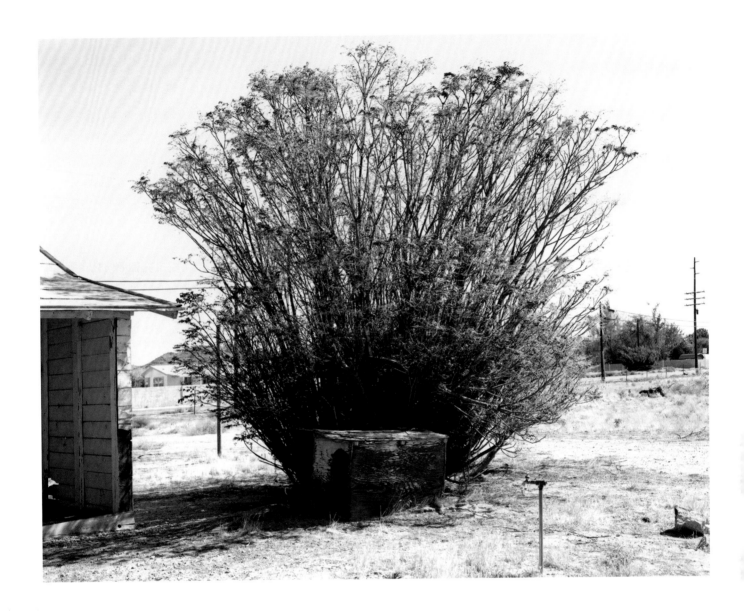

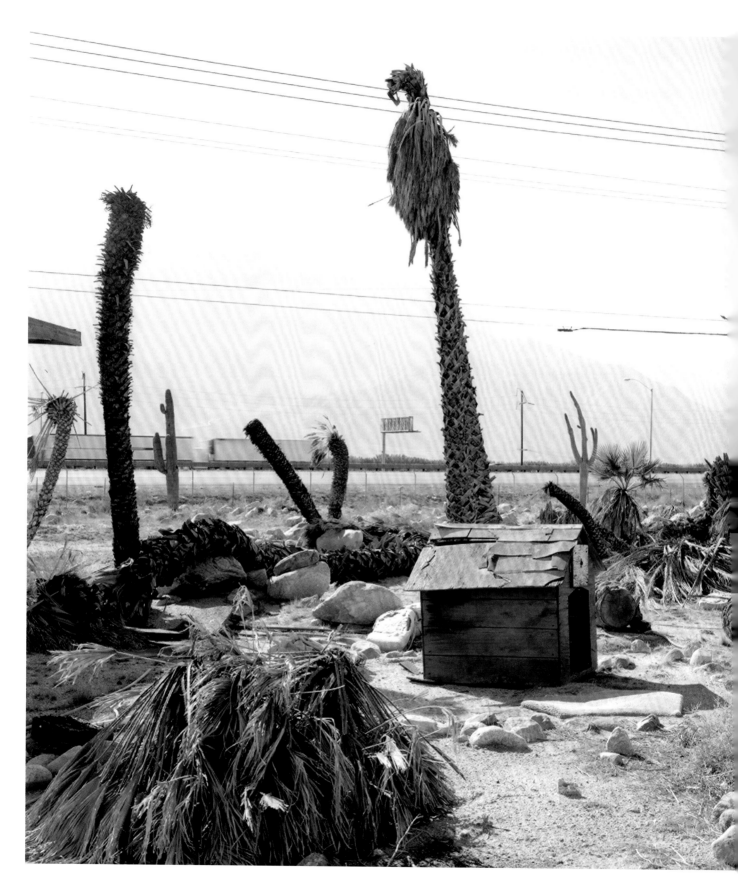

DOG HOUSE #4 (PALM SPRINGS, CA), 2005

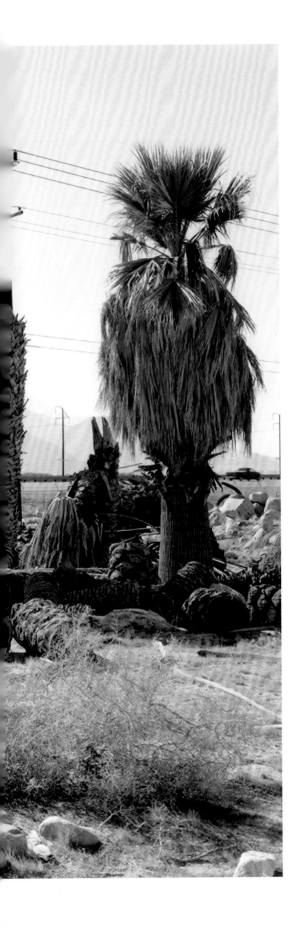

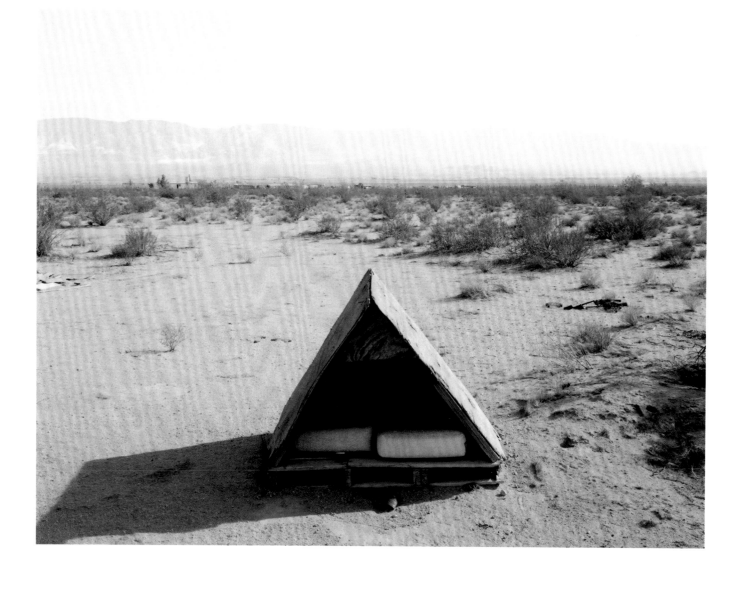

DOG HOUSE #16 (LUCERNE VALLEY, CA), 2007

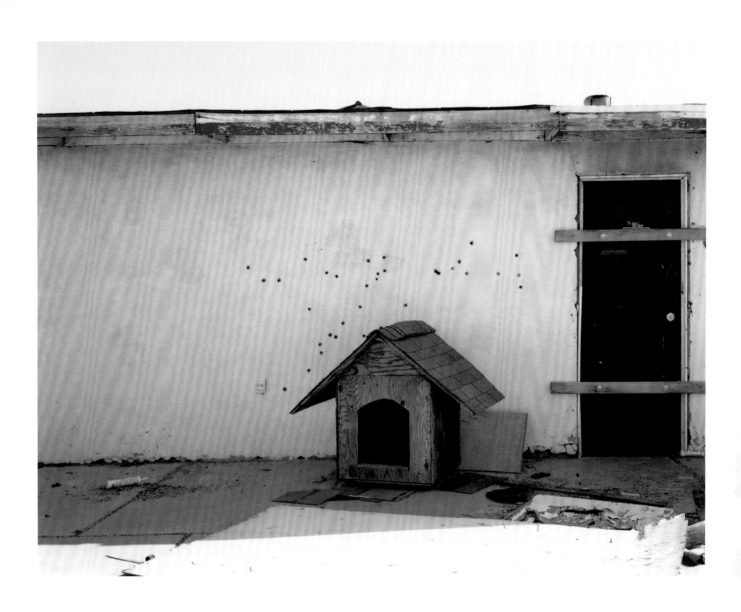

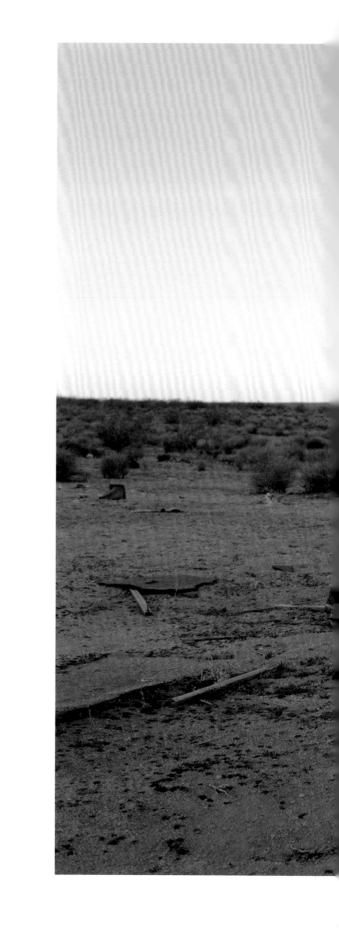

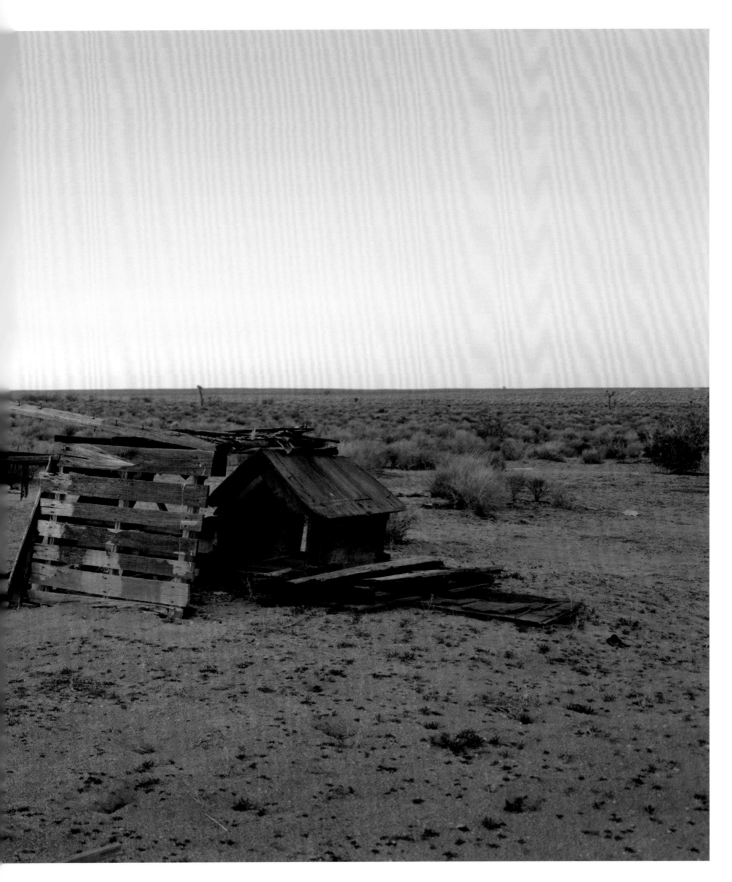

Dougie Wallace

PAPARAZZI-STYLE SHOTS OF THE CANINE ELITE,
AS PREENED AND PAMPERED AS THEIR
DIAMOND-ENCRUSTED OWNERS

'Many of the dogs display extraordinary expressions ... exasperation and arrogance are there, perhaps even the resentment we are more familiar with from paparazzi snaps of celebrities.'

It was while he was photographing the Rolex-studded pedestrians of Milan's notoriously swanky Quadrilatero d'Oro – or 'golden rectangle' – just north of the city's Duomo, that Dougie Wallace discovered the strange world of the canine mega-elite. These are dogs as primped as their owners and just as likely to be wearing Burberry or lazing on the back seat of a Ferrari.

At the time, this world-renowned street photographer had been on the hunt for super-rich human prey, in the hopes of expanding his series *Harrodsburg*, which pictures the economic privilege on display in London's most affluent areas, such as Knightsbridge, Chelsea and Mayfair. He was inspired to make the series when he learned that the life expectancy of those who live in these ultra-posh districts is around eighty-five, compared to fifty-five in the area of Glasgow in which he grew up.

Having made his name by photographing in extreme close-up and using lots of flash (both the stags and hens of Blackpool and the hipsters and wide-boys of Shoreditch have been subject to his visceral visual treatment), he applied the same technique to the dogs, discovering that, if he included a glimpse of earrings, shoes and handbags in the frame when he took the picture, he could convey a tantalizing sense of their owner's wealth, too.

The photos he took in Milan, added to ones he has captured in London and Brighton, add up to the series *Well Heeled*, so titled for its pun on the dog command 'Heel!'. Because it comes at the ultra-affluent from a sideways perspective, it is less confrontational in tone than some of Wallace's previous work, in which puzzling out a phenomenon which riles or tickles him is usually key.

He takes the pictures by walking alongside the dogs and panning his camera. Sometimes, if he thinks the owner is up for it (and they were much more so in Milan than in London), he'll add to his cache by asking for a couple more shots, 'but after that, the dog is usually going crazy,' he says.

Many of the *Well Heeled* dogs display extraordinary expressions, into which it's very tempting to read human emotions. Exasperation and arrogance are there, perhaps even the resentment we are more familiar with from paparazzi snaps of celebrities. 'Making things funny makes them accessible,' says Wallace, who hopes to expand the series to include New York (he already has the title in mind, a pun on the punk band, *New York Dolls*) and Tokyo, ('because they dress up their dogs there').

Recently, he's experimented with an antidote, too, by photographing beach dogs in Goa, India. 'I don't know which of them has the best life,' he muses, 'the rich, pampered ones carried about in a handbag, or the strays, who have the freedom of the beach.' He's also considered photographing tramps' dogs (the project to be entitled *Down at Heel*), but scarcity has held him back. 'They're always in street photography from the old days,' he says, rightly, 'but when did you last see one in London?'

WELL HEELED, MILAN, 2016

Jo Longhurst

BRITISH SHOW WHIPPETS INSPIRE
A MEDITATION ON MAN'S RELATIONSHIP WITH
HIS CLOSEST ANIMAL COMPANION

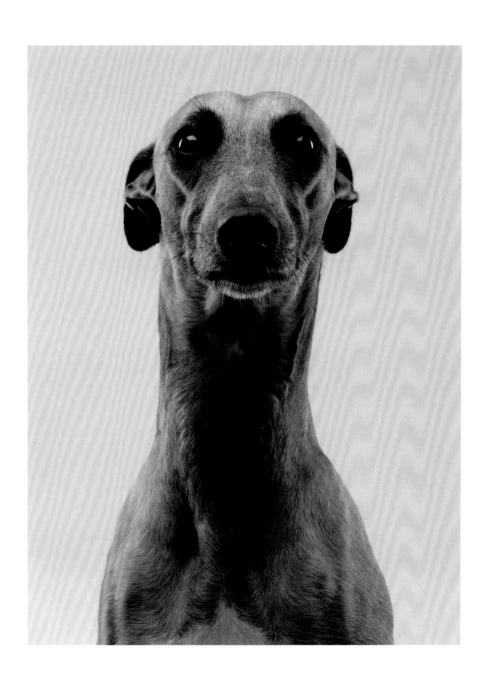

'We know we can't possibly understand dogs, and yet we feel we do, anyway.'

Like many grand adventures, *The Refusal*, a sixteen-year study of man and dog, began with a single step. Engaged in photographing twenty-four of the finest whippets in the UK, Jo Longhurst was enchanted to see one of the white bitches, at the exact moment the picture was being taken, move one leg out of the classic show stance in which she had been posed. 'It was done so elegantly,' explains Longhurst, 'but that defiance. It stayed with me.'

Twelve Dogs, Twelve Bitches, the piece she was shooting at the time, considered the way in which many dogs are now bred with appearance rather than use in mind. 'Making it all about look – the way they stand, or their colour – has sometimes been at the expense of their temperament,' Longhurst says. 'It's shaping us as well as them – I wanted to play around with that.'

Since then, *The Refusal* has flourished into a huge body of work with more than twenty chapters. Its underlying theme is the role of the domestic animal, but Longhurst approaches her target from many directions. This means that each work in the series has a slightly different emphasis – one piece looks at our emotional connection to dogs, for example; another at the power we have over them and how we might have abused that power; another at the characteristics our two species share.

Making these works has taken her all over the country, to shows and ring-craft schools, to one-man breeders and specialist stud farms. It's quite a clannish world, and to enter it Longhurst went straight for the jugular, hooking one of the big Yorkshire breeders. 'I offered to photograph their dog with a stereo camera [a Victorian invention which fuses two flat images in a special viewer to produce a scene in 3D]. After that, I had no trouble at all.'

Shortly before she began the series, Longhurst acquired two whippets of her own, Vincent and Terence. Since then, she has acquired two more. All have cameo roles in her work, because she likes to include a ringer – a domestic dog – hidden among the champion breeds.

I Know What You're Thinking presents four whippets close up and facing the camera. It's almost impossible not to ascribe human attributes and emotions to the dogs in the pictures, which exude a sense of familiarity. She was inspired to make the piece by a photograph of the psychoanalyst Sigmund Freud with his beloved pet dog Jofi, in which each is gazing into the other's eyes. 'It's a shared mutual look, not a human looking at a dog,' says Longhurst. 'We know we can't possibly understand dogs, and yet we feel we do, anyway.'

Specifically interesting for an artist was the fact that dogs are almost entirely indifferent to their own image. For *The Refusal (Part III)*, Longhurst photographed whippets in front of a mirror. 'Humans have that anxiety about how they're going to look in a portrait – will I look a prat? What's going to happen with this photo? This, for me, was the big divide. There's a narcissism built into the human condition which dogs just don't have. There's a real freedom in that.'

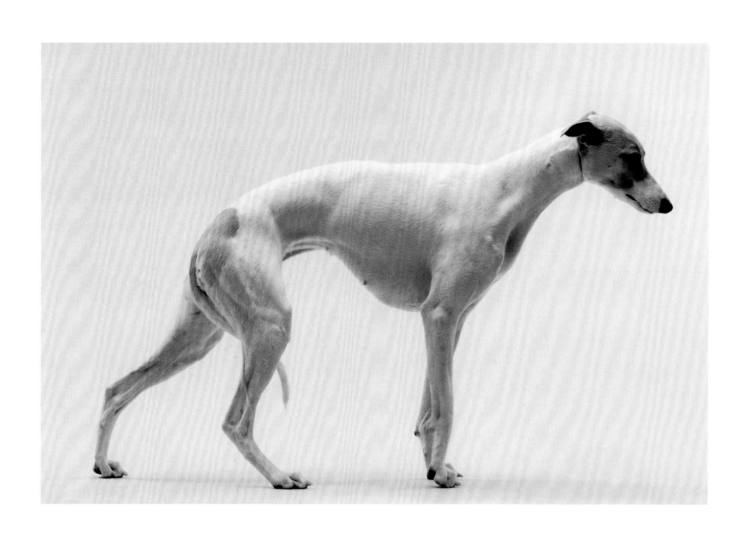

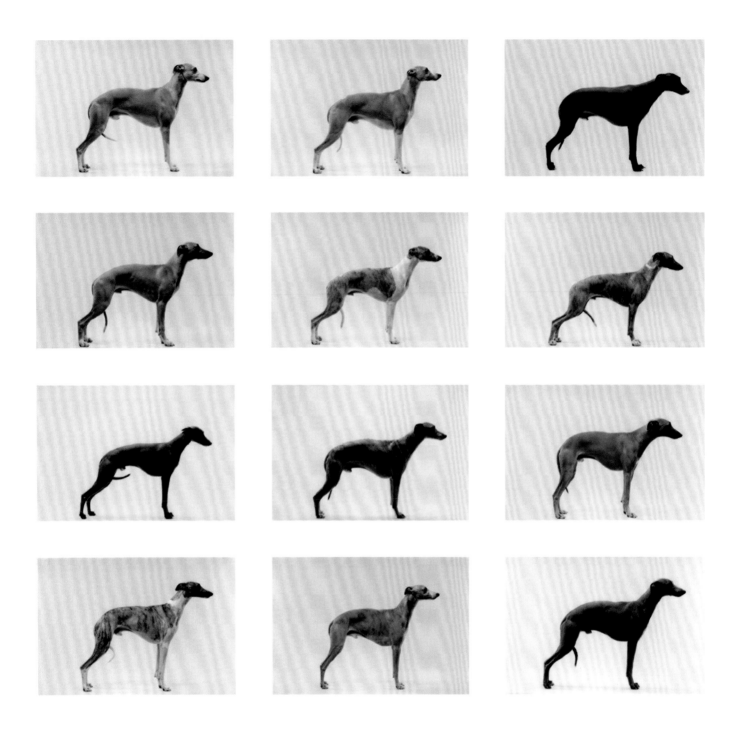

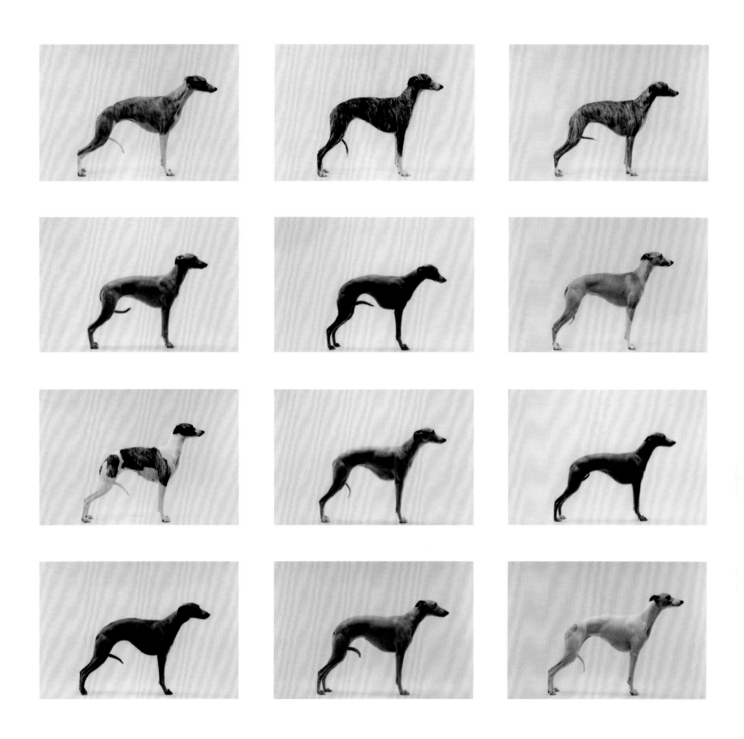

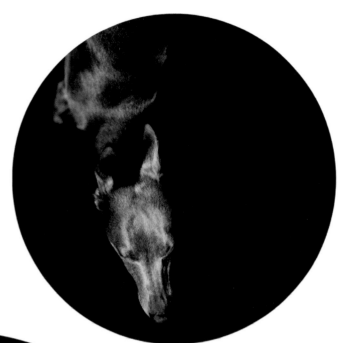

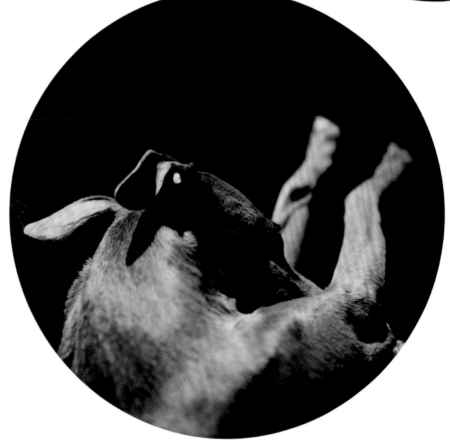

THE REFUSAL, BREED, 2005

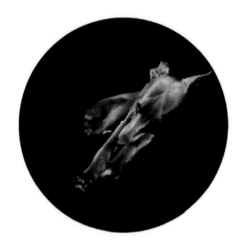

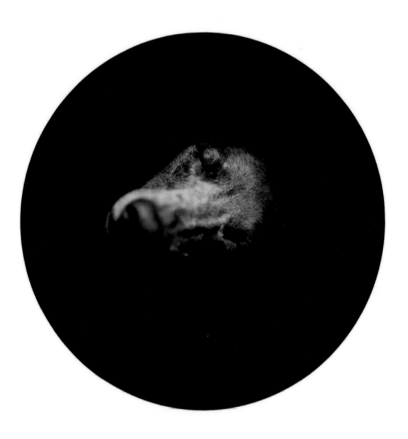

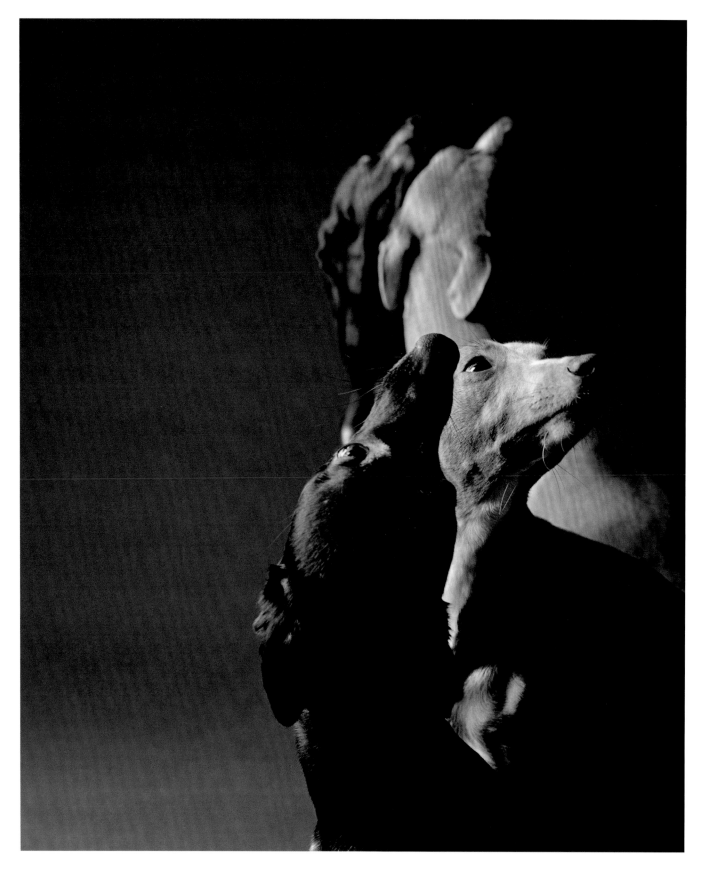

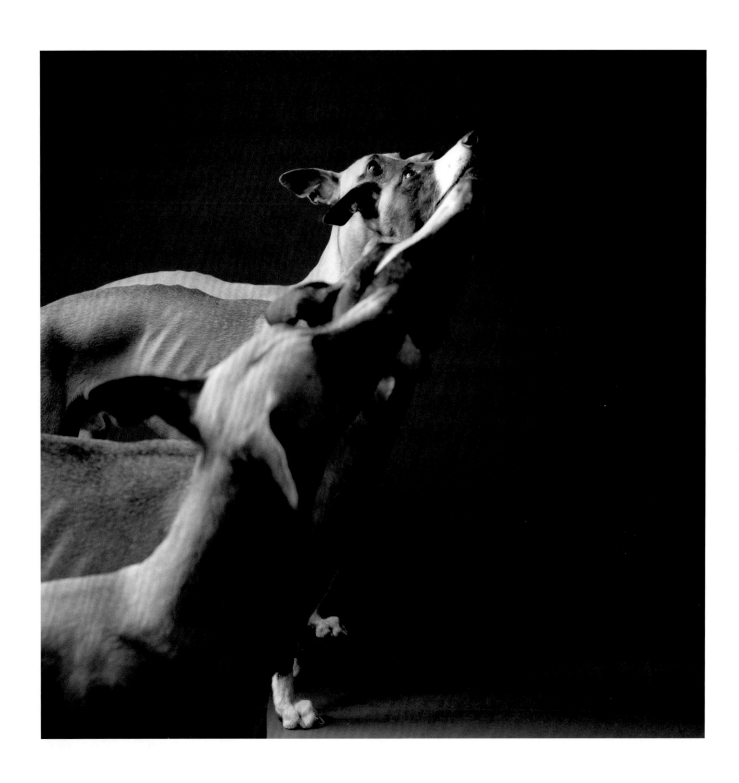

Tony Mendoza

LIFE FROM AN EGOMANIAC DOG'S POINT OF VIEW

'I became intrigued by Bob's world, and I tried to keep track of him visually. He's an egomaniac, so it worked out pretty well.'

Bob, a pint-sized and amber-haired dachshund, came barrelling into Tony Mendoza's life when he and his wife turned empty-nesters eleven years ago. 'Carmen was thinking that at this particular juncture she longed to be showered with love and attention,' says Mendoza, 'and I was hopeless – a photographer serially obsessed with his current projects. A dog sounded just about right.'

Almost immediately, Mendoza became Bob's self-confessed paparazzi. 'It becomes a fascinating thing to watch a dog if you've never lived with one before,' the Cuban-American photographer says. 'I became intrigued by his world, and I tried to keep track of him visually. He's an egomaniac, so it worked out pretty well.'

Animals have played an important role in Mendoza's artistic repertoire. The first body of work he exhibited, in 1980, consisted of pictures of his girlfriend's dog, Leela. Several were purchased by New York's Museum of Modern Art.

Five years later he published *Ernie: A Photographer's Memoir*, showcasing pictures of his TriBeCa loft-mate, a cat, alongside a conversation imagining what Ernie might say, if he could speak. It was a runaway success and still has a cult following.

'The way I photograph animals came very easily to me,' says Mendoza. 'I record him from his animal point of view. It's a simple formula: I get down to Bob's eye level and I make sure I show him in the middle of some action, involved in a dog thing in his dog world – they truly have a world of their own.'

The images provide a riveting insight into the way Bob sees himself. 'He thinks he's top dog,' agrees Mendoza. 'If he wants something, he insists, and he's certainly not wimpy.' Indeed, even as a puppy, Bob – it's short for Bowie, by the way, because he has one blue eye and one brown – would snarl and try to get into a scuffle if he saw another dog entering what he sees as 'his' neighbourhood.

'We soon learned to cross the street,' says Mendoza, who tried in vain to socialize Bob at the local dog parks. 'But that became a very nerve-wracking experience, too, because he didn't seem to understand that he was a little dog, and he would pick a fight with the big dogs. I admit I didn't help matters, because my reaction was to grab the camera and try to get a picture out of it. Those pictures are a little weird, but interesting, because they reveal a bit of that wild-dog nature that's still in there.'

Back at home, though, Bob is 'a terrific, very cute little dog'. He also, by Mendoza's reckoning, has a vocabulary of around two hundred words. 'My wife is a language teacher, so when we got Bob she figured she would try to teach him English. If you mention the word "bird", he looks up at the sky, and he exactly knows his favourite word, "beach". Bob is a great vacationer. He likes to chase crabs. Sometimes he even catches a wave.'

UNTITLED (SHE'S NOT MY TYPE), FROM THE BOB SERIES, 2009

Delphine Crépin

'Some of the balls Crépin provided took fifteen minutes to crack; others were demolished in just twenty-two seconds.'

Dogs love to chew. It keeps their jaws in shape, their teeth clean, and relieves pent-up energy. Regrettably, the habit comes with significant collateral damage. Many an owner has suffered a gutted cushion, a tooth-marked chair leg or a slobbered-on pair of shoes, making it chief among the reasons given by those relinquishing their former pets to a shelter.

Actually, it's often the owner who is to blame. Dogs are inherently sociable – we've bred them to be so – and become bored and anxious if they are left alone for more than a few hours. Breeds such as retrievers and collies, who have instinctive working skills in their veins, are more likely to feel unoccupied and act out.

Documentary maker and photographer Delphine Crépin was struck by exactly this disconnect while volunteering at an animal shelter in her home town of Poulainville, France. Astonished by the number of people who listed 'eats everything' and 'destroys all' as legitimate excuses for abandoning their dogs, she decided to see if she could use photography to challenge misconceptions concerning canine aggression.

Because chasing, fetching (and always eventually massacring) balls comes so naturally to all dogs – who hasn't seen the masticated remnants of a Penn, a Gilbert or a Mitre at the edges of their local park? – Crépin distributed an assortment of leather, plastic and rubber examples to the dogs housed in the shelter, hoping to refute prejudices which categorize certain breeds and sizes of dog as the most destructive.

Destroying objects in the name of art – particularly, to critique societal values – places her in distinguished company. Pablo Picasso once said that 'every act of creation is first of all an act of destruction', and artists Raphael Ortiz (a piano), Yoko Ono (her clothes), Ai Weiwei (a Han Dynasty urn) and Michael Landy (every one of his 7,227 possessions) are just some of those to have taken him quite literally at his word.

Some of the balls Crépin provided took fifteen minutes to crack; others were demolished in just twenty-two seconds. A miniature Pinscher took ages to get a ping-pong ball in his mouth, but then crumpled it beyond recognition. A hulk of a mastiff appeared to panic when the same type of ball was placed in his cage, and let his gnashers loose only once it had been thrown for him to catch.

Once the dogs had finished, Crépin took the results of her experiment back to her studio, photographing them in such a way as to remind the viewer of trophies. 'For most people, these balls would hold no interest and they would go directly into the trash,' she says. 'But, for me, there was a real beauty in the torn fabric. They were telling a story. If people stop to read the captions under these photos, maybe they will be surprised. Rather than trying to change the behaviour of the dogs, we need to change the prejudices of their masters.'

Thomas Roma

SPIRITED, ENERGETIC SHADOWS SUGGEST HOW
DOGS MIGHT SEE THEMSELVES IN THOSE PRECIOUS FEW
MOMENTS THEY ARE ALLOWED TO RUN FREE

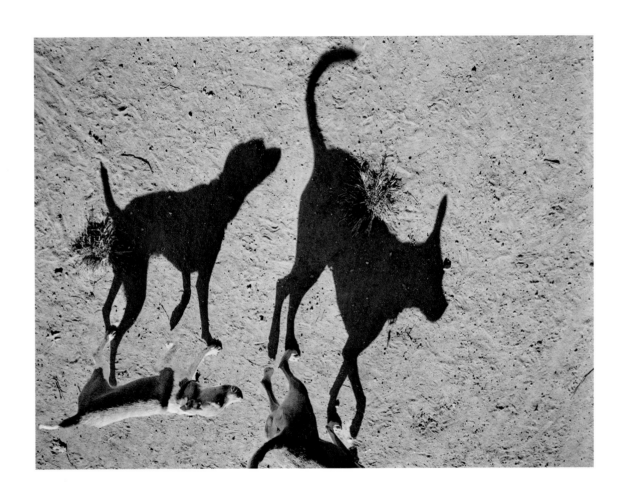

'The dogs were almost always moving, so I spent my time chasing them, pole in hand, looking quite the madman. It never became an efficient process.'

Thomas Roma's photographs capture the fleeting shadows cast by dogs as they sprint jubilantly, and temporarily off the lead, through the wilds of Dyker dog park, in Brooklyn, New York.

The series began in 2011, when Roma, a native Brooklynite and owner of standard poodle Tino noticed that, when seen in silhouette on the park's uneven ground, the dog's 'madcap', fluffy form became lithe and spirit-like; much more akin to his wolf ancestry than to the domesticated pet that had padded obligingly through the park gates a moment before.

Roma, a member of the loose-knit group of photographers who banded together in the seventies to become the New York School (Garry Winogrand and Lee Friedlander were fellow members), and now a professor at Columbia University, took these pictures with an eight-foot pole, on which he hung a lightened camera. He's been designing and building his own equipment since 1971, when he read that the Hungarian-French photographer Brassaï had used a certain-sized camera to make his celebrated night-time pictures of Paris. Unable to find the same, Roma fashioned a version of his own, 'mostly out of sheer stubbornness', he says.

Several visits to Dyker dog park later, Roma developed a technique whereby the camera rose over the dog to point slightly backwards and upside down. Not only did it give the pictures an aerial perspective, it also meant that Roma's own shadow never intruded into the frame. 'Generally, any human presence in the picture broke the spell,' he explains, although he has snuck in one or two of his wife, Anna, with Tino.

Depending on the season and the light, he would spend up to three hours a day in the park. Although it looks as if the dogs might have helped him out by standing still for a second, 'they were almost always moving,' he says, 'so I spent my time chasing them, pole in hand, looking quite the madman. It never became an efficient process.'

Many of the regulars got to know him well. 'No one thought what I was doing was odd, because we all love our dogs,' Roma says. 'Very often, when I explained, they would show me pictures they had taken of their dogs. And Tino was a great ambassador, because he would run right up to people and then dash off – he's kind of a clown. I used to describe him as a juvenile delinquent, but he's hardly juvenile now, though still a delinquent.'

Plato's Dogs ended after a renovation of the park replaced its untamed, pitted ground – excellent for elongating and distorting the shadows – with a uniform crushed stone. Has seizing their shadow spirits changed his understanding of dogs? 'Absolutely,' says Roma. 'It's like I tell my students: I can profess certain things to be important or useful, but the medium is your real teacher. Since making this work, not only do I see dogs differently – it's been a sort of psychological X-ray – I'm also much more sensitive to shadows. I see them everywhere.'

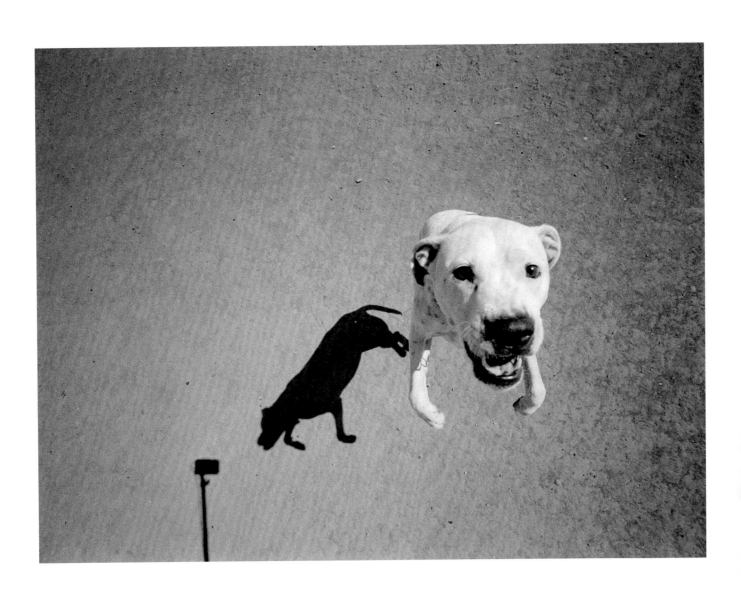

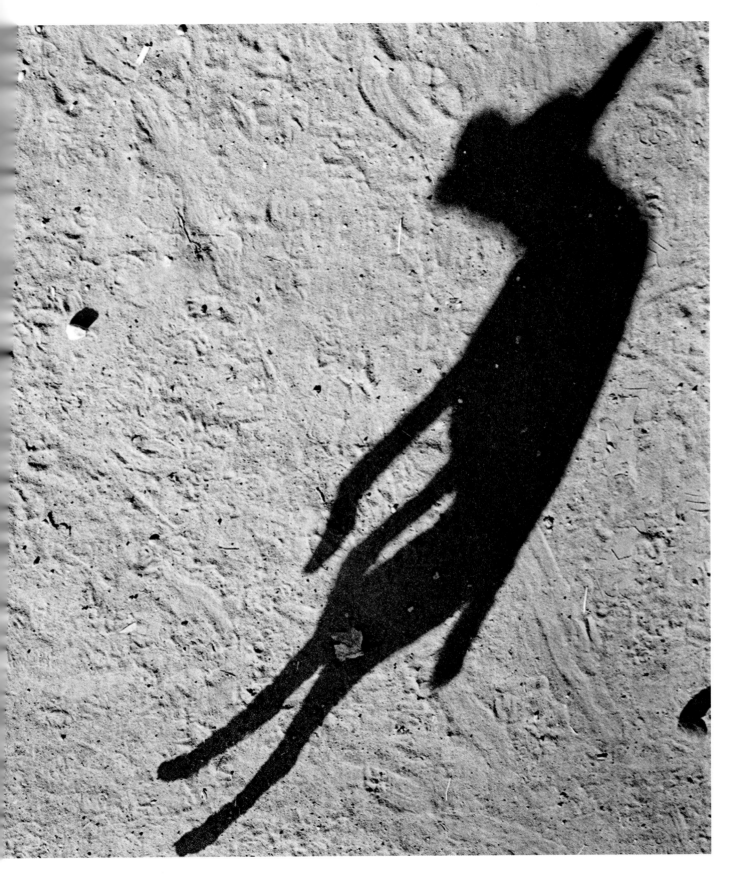

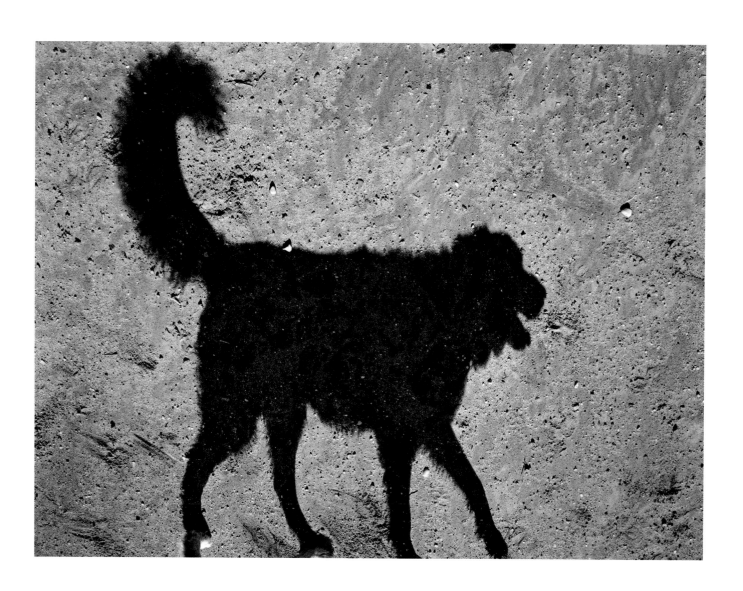

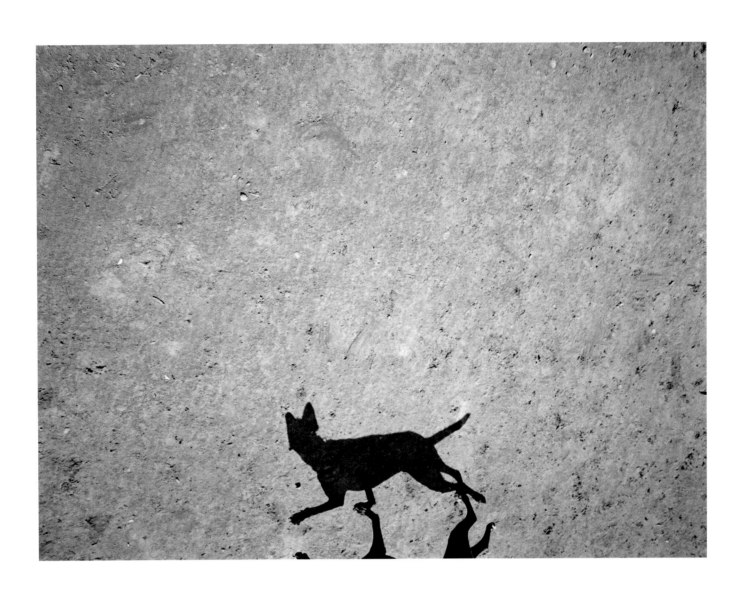

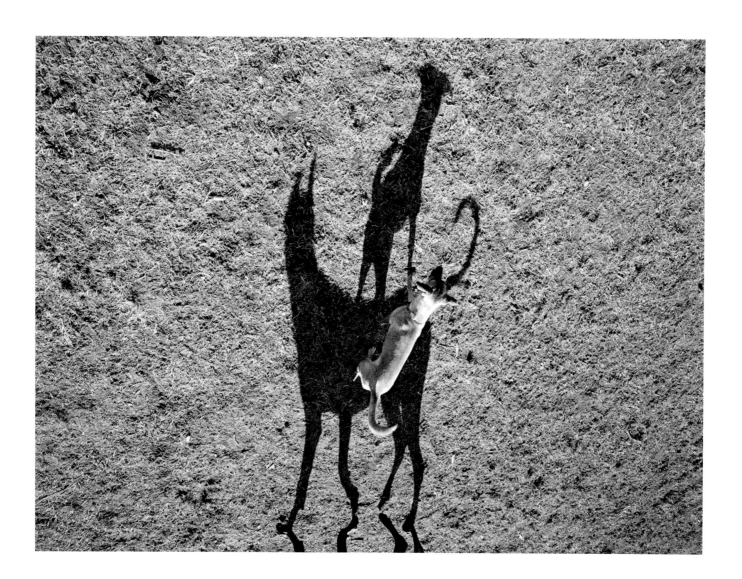

PLATO'S DOGS, UNTITLED, 2011–13

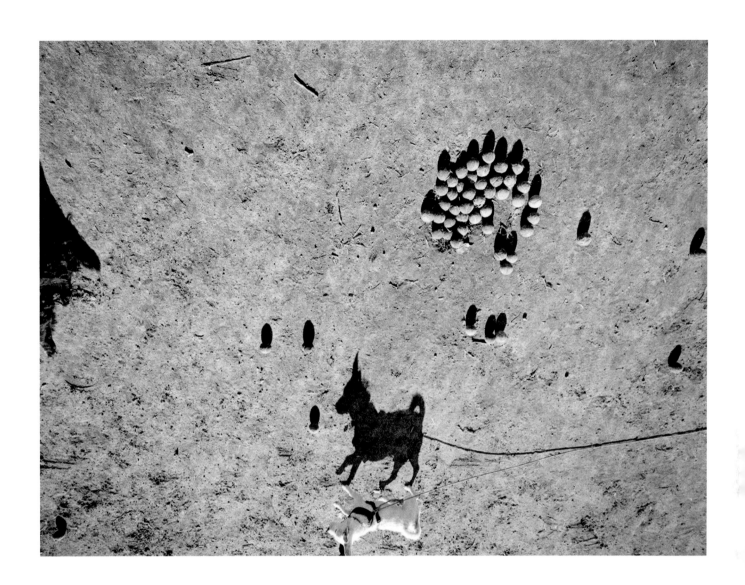

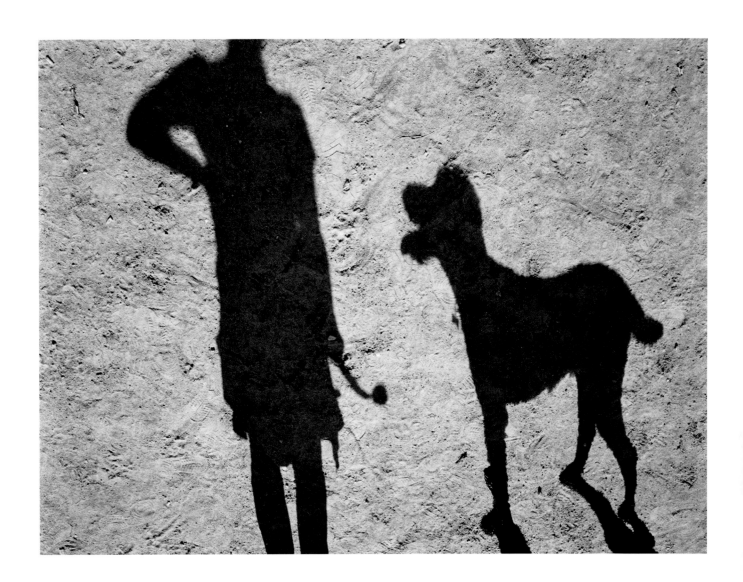

Erik Kessels

TWO DEVOTED OWNERS SPEND A LIFETIME TRYING
TO PHOTOGRAPH THEIR UN-PHOTOGRAPHABLE DOG

'Over and over again, they
used an instamatic,
point-and-shoot camera
to try to capture the
charms of their cherished
canine companion. And,
over and over again, their
efforts fell short.'

How do you photograph a black dog? It's a question that has plagued photographers ever since the camera was invented. Because, without a serious amount of fiddling with f-stop and ISO settings (assuming your camera has those in the first place), the dog is assuredly going to turn out either as a silhouette or as a black blob, missing all its discernible features.

Not that this has stopped thousands of dog owners from having a crack. Which is precisely what the anonymous couple pictured here did. Over and over again, they used an instamatic, point-and-shoot camera to try to capture the charms of their cherished canine companion. And, over and over again, their efforts fell short. Nevertheless, they preserved every one.

Of course, nowadays, when a better picture is only a delete button away, the idea of keeping a 'failed' photo is a bit of an anachronism. But not that long ago, unsuccessful attempts might be the only pictures we had of a person, or a place, or a pet. Treasuring them would be only natural.

For Dutch artist and provocateur Erik Kessels, who found the images taken by the couple in an album at a flea market and purchased it on the spot, their lifelong persistence was 'moving testament to the relationship between a pet and its owners … an epic story of love, obsession, perseverance and bad lighting.'

Kessels, who has become known – and venerated – for turning established art-world hierarchies concerning the 'value' of photographs determinedly on their head (often making us laugh in the process), particularly likes the one showing a boot-shaped black blob on a red sofa, 'which is so abstract, it's almost a Rothko painting', and the one where the couple tried to photograph the black dog on a black sofa. 'I mean, why?'

We also see a black splotch playing ball on the lawn, a black daub standing proudly on the stoop and an array of black shapes being embraced by one or other of the couple. It borders on the insane. How did the dog manage to evade capture for so long? Why didn't they just give up? And what on earth did the dog look like? (Fortunately, the last page of the album included an image in which the owners had over-exposed, producing a bleached-out photo which finally unmasked the elusive pooch.)

The album was jam-packed, furnishing Kessels with enough material to publish a book. It's volume number nine in a limited-edition series entitled *In Almost Every Picture*, which celebrates the stories to be found in the inadvertently and often miraculously repetitive content of amateur photography.

As of today he has almost twenty thousand old albums in storage waiting for his attention. Sometimes people even turn up on his doorstep to donate them. His endeavour has a bittersweet note, though, because there are far fewer albums around today than when he started, fifteen years ago. 'In a few years more, there will be none,' he says. 'I used to only buy the interesting ones; now I buy anything I find. Even in the most seemingly boring albums you might find a story and help find it a new life.'

Ollie Grove & Will Robson-Scott

PORTRAITS OF DOGS WITH THEIR OWNERS IN LONDON,
NEW YORK AND LOS ANGELES REVEAL JUST HOW
SPECIAL THIS AGE-OLD RELATIONSHIP CAN BE

'The pair were inspired by photographs from the Victorian era, when besotted owners would take their dogs to studios specializing in family portraits.'

In Dogs We Trust is a survey of modern-day dog ownership. It was created by photographers Will Robson-Scott and Ollie Grove, who met as teenage skateboarders on London's South Bank in the eighties and have been friends ever since.

Grove, who admits to being 'slightly obsessed with dogs', says the series 'came from love of a good portrait, love of a good analogue camera and love of dogs – combining all three seemed obvious'.

The pair were also inspired by photographs from the Victorian era, when besotted owners would take their dogs to studios specializing in family portraits to have their canine connection captured for all time, usually in front of a staged scene and in full stovepipe hat and necktie regalia.

'We wanted to do a twenty-first-century spin on that,' explains Grove, 'to show how much both the variation in breeds and the way people style themselves have expanded. The trouble is, once you start something like that, it's sort of endless.'

When the series began, both photographers were based in London (Robson-Scott has since relocated to New York), and would attend each shoot together. Their criteria for subjects, says Grove, was 'like Lucian Freud when he chose people he wanted to paint: he saw something in their face or something about them that intrigued him'. Robson-Scott agrees: 'We wanted people of interest, whether that was a person in the public eye or someone who grabs your attention walking down the street.' 'And devoted to their dogs, too,' adds Grove.

After a botched start trying to take portraits of the eccentric but flatly uninterested occupants of a North London squat, the pair lucked out with a harlequin Great Dane spotted on the streets of Camden, whose owner wore a schoolgirl costume emblazoned with Hello Kitty images. They followed suit with a gentleman who raced huskies on a wheeled cart in Tring, Hertfordshire, and celebrities such as Simon Callow and Ricky Tomlinson. From there, it was simply a case of following a trail – one person introduced them to the next, or suggested another subject, and so on.

During the summer of 2009 Grove and Robson-Scott flew out to Los Angeles to capture canine owners on America's West Coast on film. The trip included a visit to the SS Kennels in Compton, where bully dogs (muscular-bodied, short-coated types, such as pit bulls or Staffordshire bull terriers) are bred and sold.

'I was terrified,' says Grove, 'entering this place associated with gangland, as a sunburned blond and in a rented car that looked like a toaster, but it taught me not to judge, because what we found was a bunch of guys who had discovered peace by becoming breeders. The bond which develops – it can be really special.'

Robson-Scott has since acquired a pit bull of his own, Harmony, 'although she's not very harmonious at times,' he says. Grove thinks his lifestyle is still too unsettled to own a dog. 'There's nothing more unfair on a dog than leaving it alone for seven hours a day,' he explains. 'Taking in a dog is as important a decision as choosing to have a child. I don't live by a park, I travel, I ride a motorbike. I guess I could get a sidecar? That would be cool.'

IN DOGS WE TRUST, JESSIE AND ARCHIE, HAMPSTEAD, LONDON, 2009

OLLIE GROVE & WILL ROBSON-SCOTT

Andrew Fladeboe

PORTRAITS OF WORKING DOGS IN THEIR
NATURAL ENVIRONMENT PROVIDE A GLIMPSE
OF OUR PASTORAL HERITAGE

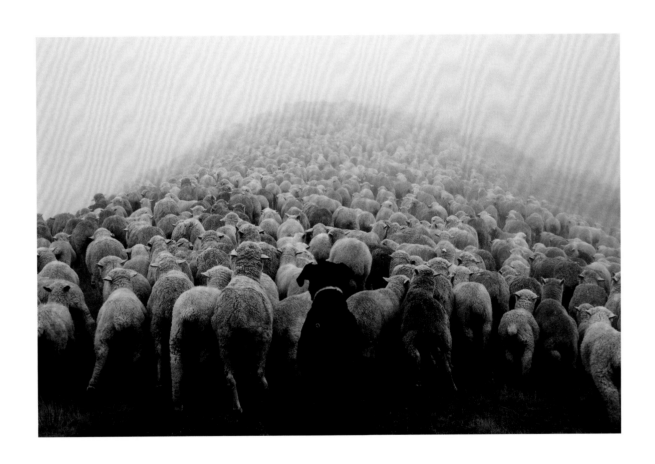

On childhood visits to New York's Natural History Museum, Andrew Fladeboe loved to wander among the dioramas – those vivid presentations of the natural world in which stuffed animals are placed in a three-dimensional foreground and in front of a painted backdrop, to lend the illusion of distance.

They stood Fladeboe in excellent stead when he began work on *The Shepherd's Realm*, a series of photographs in which he presents working dogs in the specific landscape in which they perform their task. 'I think of my work almost as photo translations of a diorama scene,' he says.

The series isn't limited to shepherd dogs – its title is meant to suggest a 'pastoral past' that we all share, far back in time. Fladeboe was inspired to begin while on an artist's residency in the Scottish Highlands in 2011. Here, he met Molly, a mixed-breed dog who protected the local farm's free-range chickens from foxes and other beasts. 'Her care-taking attitude and her free-roaming spirit (I never saw her on a leash) formed a picture in my mind of what the perfect pastoral dog should be,' he says. 'Loyal, protective, loving, sagacious.'

Two years of research followed, in which he fell head over heels 'with dogs and their history. Before the 1800s, most dogs served a purpose, and were bred for that purpose, not for arbitrary physical traits in mode at the time.' His findings led him to the conclusion that 'no one was photographing dogs in the way that I saw them – I knew I could do it in a different way'.

The project began in earnest in 2013, in Norway, where Fladeboe has ancestral roots. He concentrated on dogs belonging to farmers and breeders, whom he contacted via internet forums. He found the landscape there 'grand, often sublime … without that, the photographs wouldn't have so much power'.

Next on his list was New Zealand, which has the second-highest population of working dogs in the world (Russia has the first highest). 'Farms in New Zealand are busy places so it took more convincing on my part to get access,' he says, 'but I volunteered to work in exchange for room and board at my first stay, and then I relied on word of mouth.' Shorter stays in France, Scotland and the Netherlands followed.

As the series grew in scope, he became fascinated by the fact that we still rely on dogs so much. 'It's amazing, in this technology-focused era, that animals can do some jobs better than us or our machines,' he says. 'Dogs have been by our side for at least thirty thousand years, evolving to help us in a number of working roles. They straddle the line between man and nature, and are a perfect conduit to illustrate nature's greater power, in contrast to our human-centric point of view. To me, they are proof of a greater order to things.'

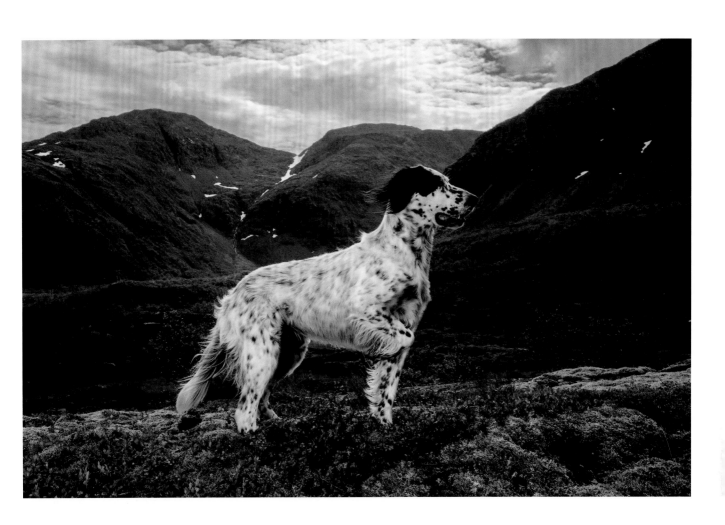

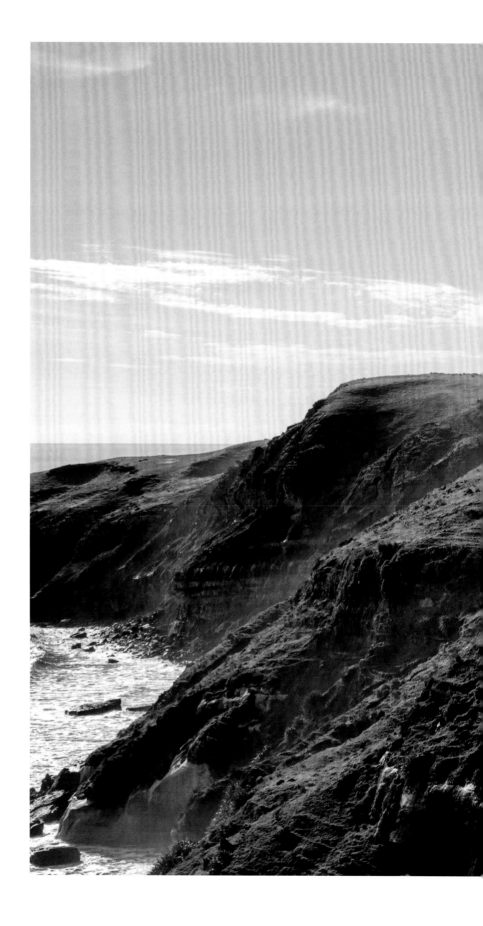

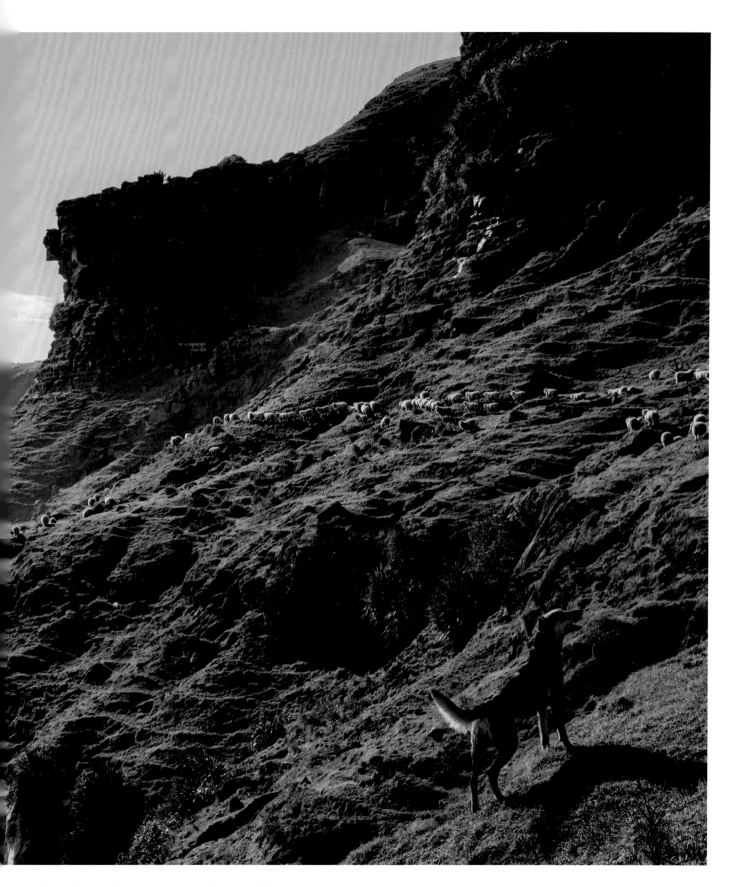

Hajime Kimura

HOW A LITTLE BLACK DOG SOFTENED THE
HEART OF A GRUMPY OLD MAN

'I found I had something more interesting to say about my relationship to my father when the dog came between us.'

Four years before he died of a terminal illness, Hajime Kimura's father acquired a little black puppy with a white belly who he named Kuro ('black' in Japanese). He had never owned a pet before, and he and the dog became devoted companions, spending every waking moment together. They even slept in the same bed.

Kimura's father was naturally taciturn by nature, a private and sometimes stubborn man. Having been widowed several years previously, the onset of retirement, followed swiftly by his children flying the nest, meant he often felt lonely. 'As time passed, he became smaller and smaller,' says Kimura, who returned to the family home in Chiba prefecture, near Tokyo, for the end of his father's life. The pair hadn't been on good terms for a long time, so the homecoming was laced with its own set of difficulties.

Within a few days, Kimura realized that no one had taken any pictures of his family for almost ten years. He decided to photograph his father, hoping that, in the process, their rift might heal. Naturally, Kimura's focus soon shifted to include Kuro. The little dog seemed at times to be almost son to Kimura's father, conjuring long-forgotten memories from Kimura's own childhood. 'I found I had something more interesting to say about my relationship to my father when the dog came between us,' he says. 'It made the images more than just family photos.'

After Kimura's father died, the grieving Kuro spent every night on his bed. 'He always chose the blanket my father used to use, even after it had been washed,' says Kimura. 'And he always sat on the chair my father had liked to sit in. Later, we found he had taken some of my father's belongings to his nest in the garden.'

Ordinarily, Kimura's father and Kuro would walk in the rice fields surrounding their home for two hours each day. Feeling at a loss, Kimura began to do the same. 'The dog always traced the same route,' he says. 'Sometimes I let him off the lead when no one else was around. He would walk home using his nose. If I stopped walking behind him, he would stop, too, and wait.'

While on their rambles, Kimura would sometimes meet fellow dog walkers his father had spoken to on his daily excursions. In the stories they told him, Kimura discovered a different side to the man he had known. 'In a way, it was the dog that showed me his veiled side,' says Kimura. 'He helped to connect us.'

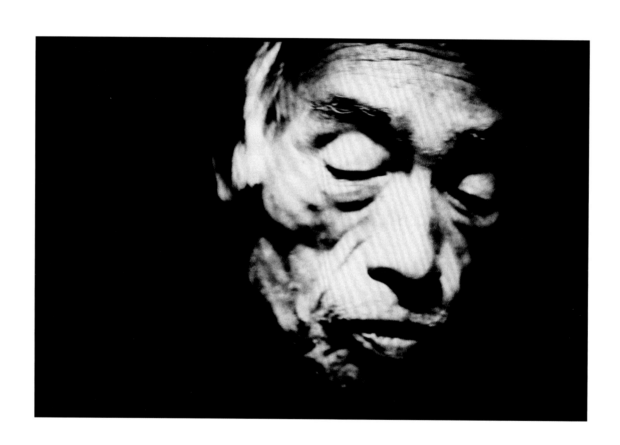

SNOWFLAKES DOG MAN, CHIBA, JAPAN, 2012

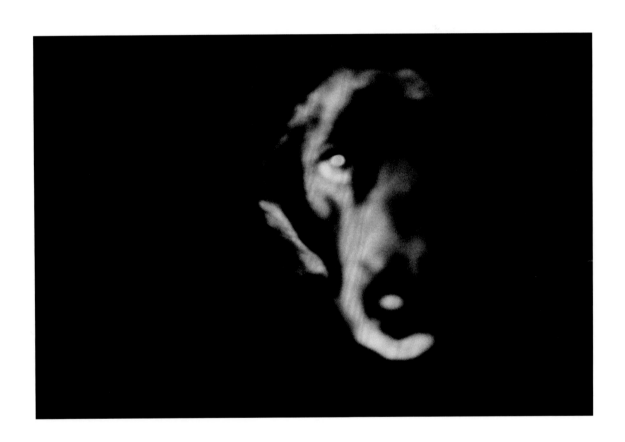

SNOWFLAKES DOG MAN, CHIBA, JAPAN, 2012

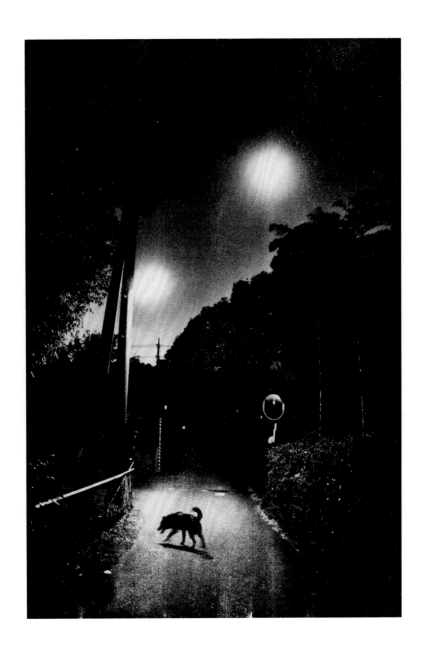

SNOWFLAKES DOG MAN, CHIBA, JAPAN, 2012

Nancy LeVine

WATCHING THE GRACE WITH WHICH HER
BELOVED DOGS AGED OFFERED LEVINE A LESSON
IN ACCEPTING HER OWN MORTALITY

The 'tight cord of love' between dogs and humans has long been of special interest to Nancy LeVine. In 2002, she published *A Dog's Book of Truths*, a visual study of the ways in which her own two dogs, Maxie and Lulu, connected with the world around them. 'We're all beings on the planet, with multilayered feelings,' she says.

Four years later, as she watched the now late Maxie and Lulu advance into old age, LeVine became fascinated by the grace with which the dogs accepted their new-found fragility. Whether they knew what was on the horizon was impossible to ascertain, but it came at a time when she was herself of an age to begin imagining her mortality.

Seeing how the dogs did it, 'how, without the human's painful ability to project ahead and fear the inevitable, the dog simply wakes to each day as a new step in the journey', made her consider 'how much I wished I was more like a dog, because while one of the best things we have is our ability to understand the past and anticipate the future, it's a very difficult thing for us to live in the present. Dogs do that as part of who they are. They fully embrace the moment they're in, rather than thinking about the body they had two years ago or what's going to happen down the road.'

As the lives of her beloved dogs – she calls them her muses – necessarily began to narrow, so LeVine became inspired to widen the scope of her study to include 'senior' dogs all over the United States. Via word of mouth and phone calls to vets and sanctuaries, she spent the next twelve years covering every region. Not long after she began, Lulu and Maxie passed away, but LeVine didn't give up. 'It was very painful, but I didn't shy away from it, I lived in it.'

A former fashion photographer, LeVine cast her canine subjects in the same way she once cast people. 'It wasn't ever the model-ly girl I was looking for, rather someone who had a depth about them. All the dogs were wonderful, but there were some who conveyed something of themselves … via their eyes, their expression, their body language; and those were the dogs that created the strongest portraits.'

Although the project has since slowed down (she published *Senior Dogs across America* last year), LeVine keeps her initiative alive via Instagram, which also features her current dogs, Sosie and Herbie, aged nine and ten. Often, owners of senior dogs will be in touch. 'It's a really interesting community,' she says, 'all about love, and a kind of solace.'

One of the things she found most moving about her series was when she would take a senior dog back to its favourite place. 'Because many of them were weak, they might not have visited this place in a while, but when we got there their bodies came alive again. They would move forth with the energy of a young dog into the space. It was beautiful to see.'

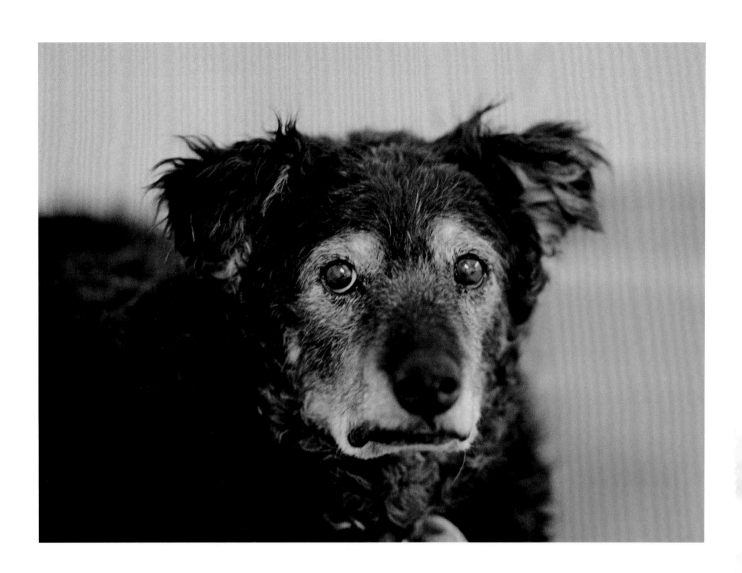

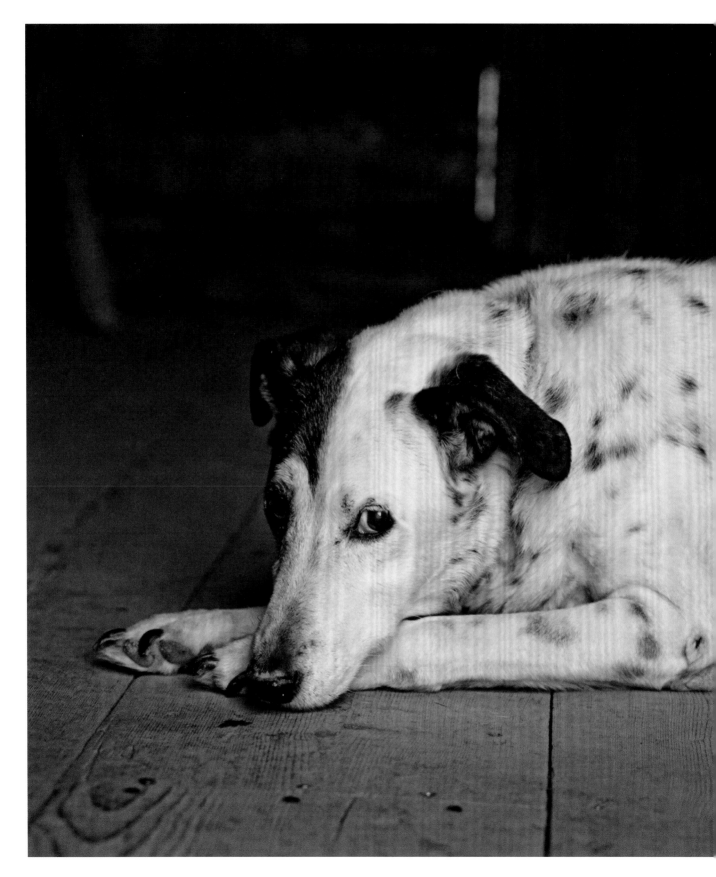

SENIOR DOGS ACROSS AMERICA, TOBY, 17 YEARS OLD, CODY, WYOMING, 2007

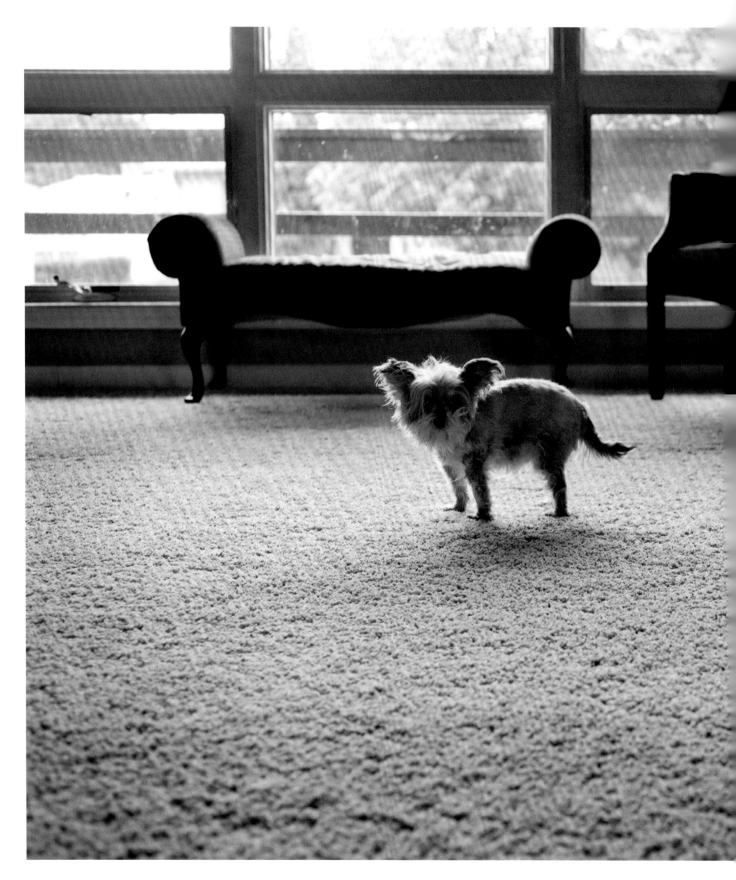

SENIOR DOGS ACROSS AMERICA, GUSSY SUE, 15 YEARS OLD, MONTANA, 2007

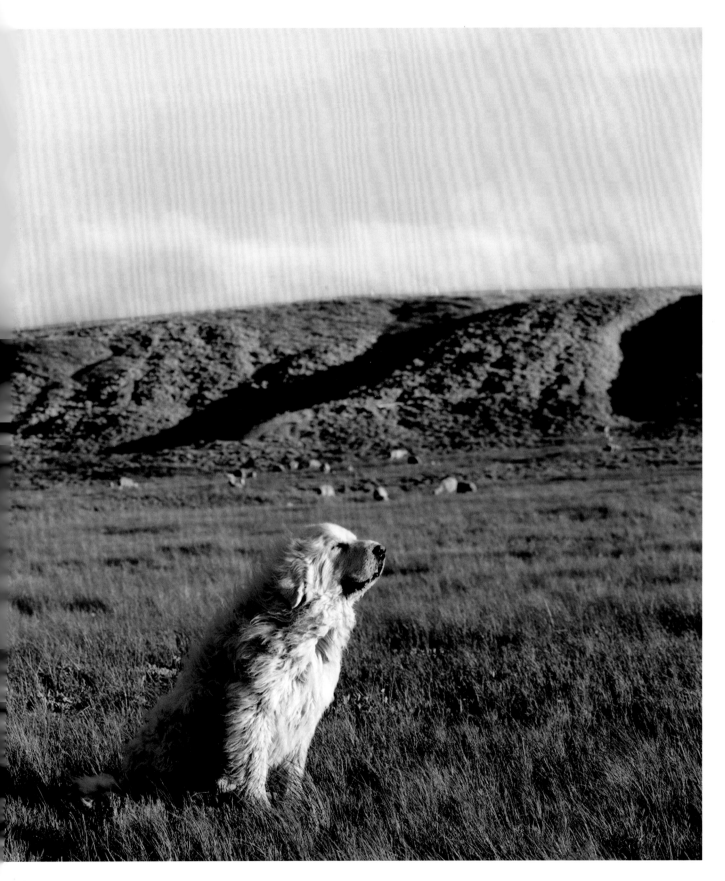

Credits

Page 6: John Thomas (1838–1905), untitled image from c. 1875,
Courtesy the National Library of Wales
Page 7: *Eos*, 1841 (oil on canvas), Edwin Landseer (1802–73)
/ Royal Collection Trust © Her Majesty Queen Elizabeth II,
2017 / Bridgeman Images
Page 8: *The Emperor Charles V on Horseback in Mühlberg*,
1548 (oil on canvas), Titian (Tiziano Vecellio) (c.1488–1576)
/ Prado, Madrid, Spain / Bridgeman Images
Page 9: *Las Meninas*, c.1656 (oil on canvas),
Diego Rodriguez de Silva y Velázquez (1599–1660)
/ Prado, Madrid, Spain / Bridgeman Images
Page 10: *Nice Pool*, Slim Aarons (1916–2006), 1955
Image courtesy Getty Images
Page 11: Courtesy Martin Parr
Page 12: *A Sunday on La Grande Jatte*, 1884–86
(oil on canvas), Georges Pierre Seurat (1859–91)
/ The Art Institute of Chicago, IL, USA / Helen Birch
Bartlett Memorial Collection / Bridgeman Images
Page 13: © Adam Ferguson, Courtesy *National Geographic* Creative
Page 14: Dog; galloping; white racing hound, Maggie,
between 1884 and 1887. Photo by Eadweard J. Muybridge
/ George Eastman House / Getty Images
Pages 17–23: © Charlotte Dumas,
Courtesy Andriesse Eyck Galerie, Amsterdam
Pages 25–37: © William Wegman
Pages 39–47: © Traer Scott
Pages 49–57: © Alec Soth / Magnum Photos
Pages 59–65: © Raymond Meeks & Adrianna Ault
Pages 67–75: © Landon Nordeman
Pages 77–81: © Tim Edgar
Pages 83–93: © Sophie Gamand
Pages 95–103: © Daniel Naudé
Pages 105–113: © 1987 The Peter Hujar Archive LLC,
Courtesy Pace/MacGill Gallery, New York and
Fraenkel Gallery, San Francisco
Pages 115–123: © Robin Schwartz from
Amelia & the Animals, Aperture, New York
Pages 125–131: © Ruth van Beek,
Courtesy of The Ravestijn Gallery, Amsterdam
Pages 133–139: © Matthew Gordon
Pages 141–153: © Tim Flach, from *Dogs*,
published by Abrams, an imprint of ABRAMS,
www.abramsbooks.com and *Dogs Gods* published
by Hachette Australia (an imprint of Hachette
Australia Pty Ltd), www.hachette.com.au.
Used with permission of PQ Blackwell Ltd,
www.pqblackwell.com
Pages 155–165: © Elliott Erwitt / Magnum Photos
Pages 167–175: © Martin Usborne
Pages 177–183: © John Divola
Pages 185–195: © Mark Ruwedel,
Courtesy Gallery Luisotti, Santa Monica
Pages 197–205: © Dougie Wallace / INSTITUTE
Pages 207–215: © Jo Longhurst
Pages 217–227: © Tony Mendoza
Pages 229–233: © Delphine Crépin
Pages 235–245: © Thomas Roma
Pages 247–255: © *In Almost Every Picture #9*,
Courtesy Erik Kessels, KesselsKramer Publishing
Pages 257–267: © Ollie Grove & Will Robson-Scott
Pages 269–277: © Andrew Fladeboe,
Courtesy Peter Hay Halpert Gallery, New York
Pages 279–291: © Hajime Kimura
Pages 293–303: © Nancy LeVine

About the Author

Lucy Davies writes about art and photography for
the *Telegraph*, where she is a Commissioning Editor.
She has written widely on visual art for numerous
books, exhibition catalogues and magazines.

Acknowledgements

I'd like to dedicate this book first and foremost to all dogs,
everywhere. If you were to randomly arrive on this earth
from outer space, and happen to land on four legs with
a wagging tail, the chances are you'd end up as a stray
without great prospects. There are more stray dogs in this
world than pets and yet our perception of dogs is so often
through the comfortable, furry lens of family life. I hope
this book goes some way to honouring the complexity –
and difficulties – that so many dogs face in this world
while also celebrating their beauty and the richness that
can come from a positive relationship with us humans.

Needless to say, there are many humans I have to
thank too, not least my wife and publishing partner, Ann
(we are in Hoxton Mini Press together, always), Helen
Conford, for being excited about what we do and having
the vision to make the partnership happen, Lucy Davies
for her tireless effort and beautiful writing, Marta Roca
for her creative advice on all things dogs and art and for
her wonderful magazine *Four&Sons*, Ruth Brooks for her
hard work (and suggesting the title) and of course all of
the truly incredible artists who have agreed to be in this
book and who have made it what it is.

Martin Usborne